ATHERTON COLLIERIES

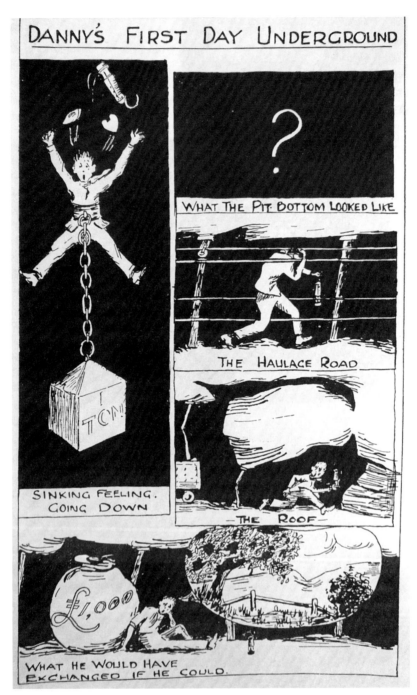

One point is obvious from researching Atherton Collieries: that some of the directors had well defined senses of humour and ensured it found its way into *Carbon* magazine regularly. Here, in April 1932, after the formation of Manchester Collieries, Clement Fletcher, as editor, includes a humorous sketch on a boy's first day down the pit.

ATHERTON COLLIERIES

ALAN DAVIES

AMBERLEY

First published 2009

Amberley Publishing Plc
Cirencester Road, Chalford,
Stroud, Gloucestershire, GL6 8PE

www.amberley-books.com

Copyright © Alan Davies, 2009

The right of Alan Davies to be identified as the Author
of this work has been asserted in accordance with the
Copyrights, Designs and Patents Act 1988.

ISBN 978 1 84868 489 8

British Library Cataloguing in Publication Data.
A catalogue record for this book is available from the
British Library.

Typeset in 10pt on 12pt Sabon.
Typesetting and Origination by FONTHILL MEDIA.
Printed in the UK.

Contents

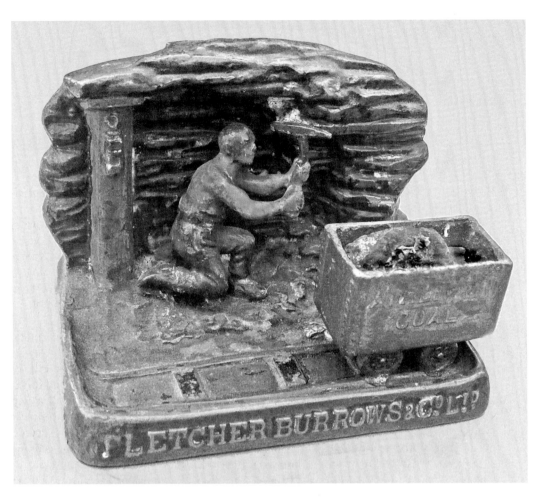

Fletcher Burrows & Co. had a great respect for their long service employees and offered them a variety of gifts. One item offered was this pipe stand, match box container (the tub) and striker (on the back). The tub has Atherton Coal embossed on it. The miners' lamp hangs on the pit prop.

Acknowledgements

Many people have passed on their knowledge of the coal industry in Atherton over the years and continue to do so, for which I am always grateful.

Those I can remember and who deserve a special mention include Ken Wood, former journalist and author of *The Coalpits of Chowbent*; Donald Anderson, late mine manager and owner, surveyor and mining historian of national renown; Tony France, mine surveyor and mining historian, former NCB and British Coal area geologist. Tony has worked like a slave to provide me with all manner of sources of information, especially maps and plans; Lord Lilford for allowing me to reproduce sections of the Lilford estate plans held at the Lancashire Record Office.

Also, Jim Fletcher, former manager of Howe Bridge Colliery; John Anderson, mining engineer; Robert Evans; John Hayworth; Charles Birdsall; Joan Szymanowski for her boundless enthusiasm; Brian Coop; Terry Donnelly; Robert Cornish; the family of Allen Howcroft; Bob Jeffries, archivist at the former NCB archives at Anderton House, Lowton; the Institute of Mining Engineers; Ron Sheard; Kathleen Lawrenson; Norman Redhead, University of Manchester Archaeological Unit; Mr David Houghton; the family of Albert Leather for allowing me to use his superb photographs; mining record office staff at the former NCB, Berry Hill, Stoke; and John Gilman, former mining surveyor at Howe Bridge Colliery, and later, Agecroft Colliery.

Thanks also to my mum and dad, aunt and uncles, sadly all no longer with us, whose discussions around the kitchen table on Saturday afternoons often included mention of what was happening at the pit, namely Chanters Colliery, and probably sparked off my interest.

Preface

Coalmining, which existed through at least six centuries within the ancient townships of Atherton and Chowbent, might seem to have progressed just like those in the adjacent mining townships, with similar mining techniques and geological challenges. Why should the manner of coalmining in Atherton be any different than, say, in the adjacent town of Tyldesley? Well, it most certainly was, and the fascination for me in mining history is that every long-life colliery was operated and developed in a unique way. No two collieries in the British coalfields ever looked identical and certainly, below ground, would not be. Every colliery had its own geological and working challenges, its management and men approaching them in their own intuitive way based on generations of local knowledge.

In Atherton, the involvement over 150 years of one family in particular, the Fletchers, ensured that the collieries had a distinctive character. The arrival in Atherton of John and Matthew Fletcher in the late 1760s, and generations later, their amalgamation with the Burrows, eventually created an enterprise far wider in its scope than purely the mining of the coal. Within this initially small but important township (due to weaving and nail making), an industry was gradually created which made technical advances of national importance; one where the colliery owners caring attitude towards their workforce moulded the character and lives of a unique community for generations.

Some readers may not be aware that coalmining had ever existed in Atherton as little evidence is visible today. All the main mining-related structures have virtually gone, apart from the Gibfield Colliery pithead baths down Coal Pit Lane off Wigan Road, the mines rescue station at the bottom of Lovers Lane, and most importantly, the architectural gem of the mining village of Howe Bridge. Other clusters of miners housing still survive near Chanters Colliery, Hindsford, on Wigan Road near Gibfield Colliery and on the outskirts of Hag Fold estate.

Of national importance, the survival of the mining village at Howe Bridge, now with great relief an architectural conservation area, will ensure that this once thriving mining community and its associated services will always be remembered by future generations.

As to where my interest comes from, I was born in Atherton in 1955, attended Howe Bridge School, worked in and studied mining at Parkside Colliery in Newton, Coventry Colliery, Bickershaw Colliery in Leigh and Castle Colliery, Wigan. As a young lad on school holidays in the early 1960s, I remember seeing my uncle, Kevin Wood, coming down the steps off the pit headgear at Chanters Colliery No.2 Pit waving to me, matt-black face. Back to his house in Tydesley Old Road and sit at the table staring at him as he ate his rice pudding, his huge blue striped mug alongside. Those hands with blue scars and blackened nails, the distant look in his eyes, the coal-dust-ingrained eyelashes.

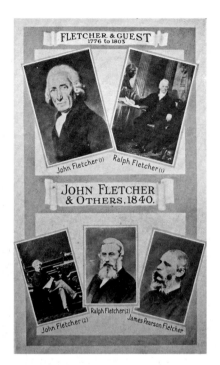

Above left: John Fletcher (1727-1806), top left, originated from Bolton, the son of coal-merchant Jacob Fletcher (*c.* 1696-1766). A typical dynamic man of the industrial revolution, he signed the Fletcher's first lease to mine coal in Atherton in 1768. His partner was a Mr Fildes, who may have been an Atherton man, who had made him aware of the potential of the Atherton coalfield. This first Fletcher activity probably took place at Far Atherton or Gibfield, working the Five Feet coal. For a number of years, he had been involved with his cousins in mining ventures at Clifton near Swinton. John's brother was Matthew, another industrial powerhouse of a man who owned mines at Clifton and used to ride over to Atherton daily to supervise sinking and development operations.

Above right: Matthew Fletcher of Clifton (1729-1808), brother to John, developed, among others, the Clifton coalmine Wet Yard Pit (later Wet Earth Colliery), working with the famous engineer James Brindley (1716-1772) on a unique water-siphon-powered pumping scheme. Using water diverted from the River Irwell and allowing for lower river levels at the site of the colliery, he sent the water below the river in a U-type siphon. Water was sent along a short tunnel near the top of the siphon upshaft to drive a waterwheel linked to pump rods. The Fletchers were always keen to make good use (and re-use) of water supplies for pumping and winding, putting that knowledge to good effect at Mole Field Colliery, Howe Bridge. The memorial to Matthew is in Ringley Church.

To me, he was some kind of hero, and I had to know all about where he worked.

Four years as an art student was fitted in amongst the mining, the art works based, of course, on aspects of mining! Then a period of in-depth study of the industry as curator of the Lancashire Mining Museum, Salford, for fifteen years until it regrettably closed in 2000. Six years as the archivist for Wigan Borough gaining qualifications then filled in the picture as regards the types of records surviving today and where they were held. Believe it or not, the records of coalmining in Atherton can be found as far afield as

Right: Carbon magazine, Vol. 1 No. 2, January 1920. The wooden headgear of 1872 stands above the Arley downcast pit. In the foreground, the boiler feed water lodge alongside Coal Pit Lane. Fletcher Burrows mentioned the expense of printing the magazine in this issue and stated that it would have to be 2*d* from now on. It still cost that much in 1935!

Below left: A very rare Atherton Collieries Joint Association members badge, probably from the late 1920s. The Association was formed in 1918 taking over Howe Bridge cricket ground and tennis courts, the village club and the bowling green. Land near Alder House was purchased in August 1918 for the football ground still in use today. In 1921, the Coffee Pot Club across the road from Atherton town hall opened; today it is a café of a similar name. There, men could play billiards, snooker, dominoes, whist and other activities. The association continued its activities for many years after the formation of Manchester Collieries in January 1929.

Below right: The irrepressible Clement Fletcher (1876-1965) was genuinely fond of and generous to his workforce and community. Here, he presents prizes at the carnival and gala of November 1928. Always loyal to Atherton, particularly Howe Bridge, he lived here when many other directors of the company chose to live in more select areas, Cheshire, for example. I was told by my father that I had sat next to him in Howe Bridge church many a time without realising.

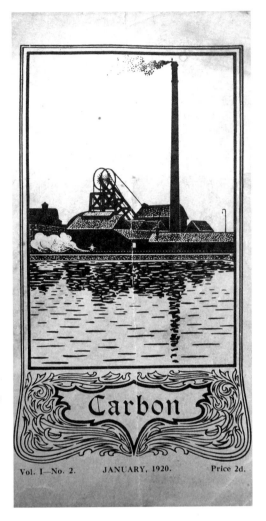

Vol. I—No. 2. JANUARY, 1920. Price 2d.

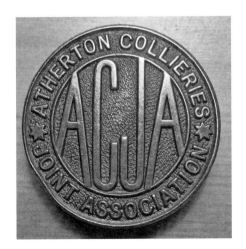

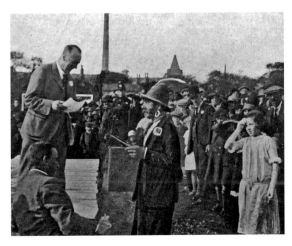

Bolton, Preston, Mansfield, Staffordshire, Nottinghamshire and London, not forgetting Wigan Record Office at Leigh Town Hall.

One of the main sources of inspiration for me has been the fascinating Atherton Collieries magazine, *Carbon*, the quarterly magazine first published in late 1919. Without access to *Carbon*, a history of Atherton Collieries would be very dry and technical. With it, the social history and unique approach brought by an amazing organisation comes to life. Even after forty years of searching for and adding individual volumes to my collection, I have only amassed twenty-three volumes and often wonder what gems of information may be found in the missing volumes. No doubt they will turn up as the book rolls off the presses!

Carbon, through the genius and enthusiasm of Clement Fletcher and Robert Burrows, educated, amused and kept informed the workforce in many areas, including the mining industry itself and its history. Clement Fletcher had a personal interest in Atherton's mining history due to his family's 300-year connection with it. He tantalisingly dipped into sources for his articles, which today, cannot always be tracked down or which may not have survived.

Also documented were the activities of the various societies affiliated with the Atherton Collieries Joint Association, unique in the wide-ranging scope of its organisation. This very active society organised day trips, carnivals, galas, public speaking and debating, gramophone recitals, musical evenings, first-aid competitions, fishing, tennis and football matches, rifle club, cricket, bowling, snooker and billiards, darts and dominoes, plays, musicals, dancing, boxing events and even a male voice choir. A library was created and made available to members, and speakers were invited to talk on subjects ranging from local, general and mining history, travels abroad (mainly by colliery management and their families, I would add) to quite detailed aspects of religion, science and geology among others. Often prominent academics and professional contacts of the colliery owners were harangued into attendance, commenting occasionally on the surprisingly high level of interest and intelligence of the Atherton audiences.

Carbon magazine survived in name after the amalgamation into Manchester Collieries in 1929, covering the interests of the wider organisation and initially still contained large amounts of Atherton-related content and advertising due to the input of Clement Fletcher. Over the years, I realised, without being too biased, that the Atherton collieries were genuinely unique in the manner in which they were operated and managed and were well worth documenting.

Ken Wood's excellent, but sadly now out of print, *The Coalpits of Chowbent* of 1984 was the first thorough study with the added skills only a very experienced journalist could bring. Ken, who had risen to the heights of deputy editor of the *Manchester Evening News*, discovered many new sources and interviewed a wide variety of people still alive who had associations with Atherton's coal industry. In those days, cost limited the inclusion of large numbers of images.

This study is a compilation of the best and most informative images, and the concise accompanying historical text will hopefully convey my enthusiasm for a subject, which so far, has captivated me for over forty-five years. Virtually all the known images relating to the coalmining industry in Atherton will be found here, drawn from three major private mining historical collections, plus my own and occasionally individual images from family collections.

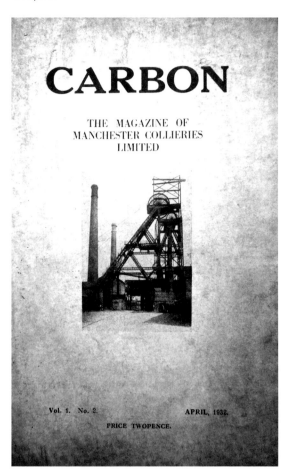

After the formation of Manchester Collieries in January 1929, *Carbon* magazine continued and still contained a great deal of Atherton interest. It now featured Astley Green Colliery on the cover. The imposing pit headgear by Head Wrightson & Co. survives today as part of a volunteer-run mining museum.

I know that compared to other colliery concerns, we are very lucky that the industry was so well documented in Atherton, most of those images covering the period 1893 to the 1960s. Earlier maps, plans, engravings and sketches have survived and will also be found within this volume.

The introductory text has been kept very concise due to the space being required for the images. Enough archival information on the progress of the business exists for a researcher to be kept busy for many years, and it has been very frustrating leaving aspects of the industry out. There are many aspects of the coal industry in Atherton over the centuries that deserve detailed academic attention, such as the Fletchers and the Burrows, the way they treated their workforce, how they actually worked the various seams, workers education and social welfare, and the technical advances they made; hopefully they will be tackled in depth in the future.

Alan Davies
Tyldesley
October 2009

Coal in Atherton and the Early Days of Mining

Detailed technical descriptions of coal formation and the peculiar language and terms used can often be totally baffling to the average reader. An advanced level of description is not needed here, but sources are listed later for those wanting more detailed accounts.

Coal seams and their associated sedimentary (layered) rocks, such as fireclays (the former soils of the coal forests), shales, mudstones and sandstones, which lie under and occasionally come to the surface at Atherton, belong to an era of geological time known as the Carboniferous period.

It is hard to believe today that Atherton, approximately 300 million years ago, was situated near the equator within an enormous river delta. The landscape was one of islands, swamps, slow-moving seas and fresh-water rivers.

Over millions of years, the river delta was flooded many times as the land slowly rose and fell. Where land was above the water, trees and dense undergrowth grew, later dying, falling, and then decaying to form peat similar to that found today on Winter Hill.

In a regular and cyclical course of events, the thick beds of peat were covered by mud and sand (today's mudstone and sandstone) and eventually sank to great depths. The resulting heat and pressure, allied to this subsidence, led to the formation of coal seams. It has been conjectured that peat formation and subsequent compression over approximately 5,000 to 10,000 years was required to form only one metre of coal.

Although rich in coal, Atherton's reserves were but a tiny proportion of the assessment by the Coal Commission in 1904 of the extent of the Lancashire Coalfield, estimated to be 4,238,507,727 tons!

ATHERTON'S COAL SEAMS

Atherton was rich in that most of the well-known and better-quality middle coal measures seams of the Lancashire coalfield, high in carbon and leaving low amounts of ash, were present within the township. Other, less high-quality coals with alternating dirt bands, the Yard, for example, were also present and would eventually have to be worked as the best coals approached exhaustion. Hand picking or separating of good coal from dirt or poor coal was carried out by the famous pit-brow women on surface conveyor belts. By the late nineteenth century, coal washing was needed to make these poorer seams saleable in a quality-conscious market.

In the list below, which shows the vertical sequence of seams, you will notice the term *mine* is used occasionally. This term has been associated with seam names for centuries and, in this context, means a coal seam as compared to a colliery.

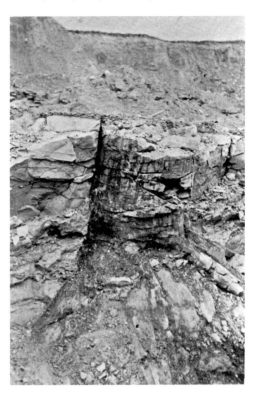

Right: A fossil *sigillaria* tree with *stigmarian* roots seen at the Swan Island (off Tyldesley Old Road) brickworks quarry around 1925. 300 million years ago, when Atherton was near the equator, these trees were swamped by mud, thus remaining upright. The hidden bases of these fossils, known by miners as 'bell pots', occasionally dropped out of the roof at the coalface injuring, or even killing, colliers.

Below: 1929 6-inch-to-a-mile geological survey sheet 94SE. The two large faults, the Lions Bridge and the Church, dislocate the strata from north-west to south-east. The abundance of coal seams outcropping across the town WSW to ESE are the thick black lines. Old pit shafts (only a few are shown) are circles with a cross; shafts in use at the time are the circles with a single line through. The dip of the seams across most of the town is shown as 1 in 5. By the mid-1940s, Chanters Colliery was working 950 yards below ground.

11 White rock	5	0	
12 Metal	65	1	
13 **COAL**	1	0	
			824 9
14 Warrant	1	0	
15 Rock	8	0	
16 Metal	15	0	
17 **COAL, inferior**	1	4	
			859 1
18 Warrant	2	0	
19 Metal and rock	33	7	
20 Strong metal	20	8	
21 Balley metal	1	0	
22 **Yard Mine (Five Quarters)**—			
J **COAL**	2	0	
			918 4
23 Soft warrant	2	0	
24 Strong warrant and metal	24	4	
25 Hard rock	3	0	
26 Metal	21	0	
27 Strong linsey	5	0	
28 Soft metal	2	6	
29 White rock	36	0	
30 **Four Foot Mine**—			
H **COAL**	3	11	
			1006 1
31 Warrant	8	4	
32 Strong blue metal ...	18	11	
33 **COAL**	1	10	
			1035 2
34 **COAL** and bass	2	0	
35 Soft warrant	3	7	
36 Metal	26	2	
37 Burr	9	8	

The shaft-sinking log for Chanters No. 1 pit documented every change in strata to the inch. Terms such as Warrant, Balley Metal, Strong Linsey and Burr had originated in the coal districts centuries earlier. The great expense of shaft sinking was offset by the invaluable insight it gave into the strata at Chanters and Atherton in general.

Some seam names are of obscure origin and meaning – Crombouke, for example – others less so, like the Six Feet. Some seams, which were well known and correlated across the whole Lancashire coalfield, took on varying names from district to district, the Arley, for example.

Bin Mine	4 feet 6 inches
Crombouke	4 feet 6 inches
Brassey	4 feet 0 inches
Rams (6 Feet)	5 feet 8 inches
Pemberton Five Foot	2 feet
Black and White (7 Feet)	7 feet 10 inches
Five Quarters	2 feet 8 inches, including 4 inches of dirt
Wigan Four Foot (or Victoria)	4 feet 3 inches
Wigan Two Foot	2 feet 9 inches
Trencherbone (Five Feet)	5 feet
Cannel Mine	4 inches
King	1 foot 8 inches
Plodder	5 feet 8 inches, with 8 inches total dirt bands
Yard Mine	5 feet 6 inches
Bone	1 foot 2 inches
Smith	1 foot 4 inches
Arley Mine	4 feet

These were the main workable seams found in the district. Many thin coals occurred in the Atherton sequence. Back in the late 1980s, in The Valley near Chanters, a thin seam of about one inch was exposed. A glance at the 1,826-foot-10-inch shaft log of Chanters Colliery No.2 Pit in Professor George Hickling's *Sections of Strata of the Coal Measures of Lancashire* (1927) shows over 15 feet in total of thin coal amounting to millions of tons over the whole Atherton coalfield. To work a two-foot-thick seam, when other, thicker seams, even ones of poorer quality, had for generations been worked, was not really viable in the 1920s. The packing or removal of the associated shale and stone would have been very expensive. That coal still lies there today, as is the case over the whole of the Lancashire coalfield.

FROM THE EARLY DAYS TO GEOLOGICAL REVELATIONS

The earliest days of organised coalmining in Atherton are very thinly documented in surviving archives. Coal is often mentioned, but where it was being worked locally is not. Compared to the large amount of archive material available after the mid-nineteenth century, I feel it worth mentioning virtually all the early references here and being more concise with later events. The photographic record from 1893 onwards allows for detailed captions alongside the images, the main reason for this publication.

In summer 2003, excavations were carried out south of Wigan Road opposite the site of Gibfield Colliery and immediately south of the former Gadbury Brickworks. The land that for generations had been one of the sites for Gibfield's waste dirt, shale and stone, and also the brickworks quarries was to be landscaped for building houses.

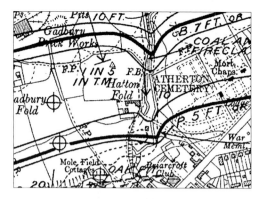

The 1929 6-inch geological survey. Thick lines indicate the outcrops of the Black and White seam and Pemberton Five Foot seam close to Gadbury Brickworks. They follow the contours of the intriguingly named Collier Brook next to the cemetery wall. Old shafts, probably ladder pits of the very early 1800s (circles with crosses), dot the landscape. Many of these shafts were still untreated in the late 1950s. Atherton probably has close to 100 old shafts in total.

Archaeologists from the University of Manchester Archaeological Unit found possible evidence for Bronze Age activity, the Manchester to Wigan Roman road, medieval smithing waste, and small-scale fourteenth-century coal and ironstone extraction (rather than organised mining).

When the first person to mine coal in Atherton was active and where, we will never know. The Romans long knew the value of coal in metalworking rather than as a fuel, and evidence can be found in most parts of Europe for their coalmining activities. Wood was favoured in houses as a fuel rather than coal until the early seventeenth century. By then, the ancient woodlands had virtually been decimated both for fuel, construction and shipbuilding.

The 7-foot-10-inch-thick Black and White seam outcrops across the site of the excavations at Gadbury and in the brook at the side of the Atherton cemetery wall down in the valley. Being at an inclination of twelve degrees meant over 30 feet of coal in a flat plane would be visible in the bed of the brook.

Depending on the period in time, miners may have deduced, in a very basic sense, the structure of the seam and shallow opencasted it along its outcrop. It is feasible that coal from shallow Black and White seam workings may have been used for smithing back in the fourteenth century; it is a good quality seam and the surface cover of boulder clay is only between 3 and 15 feet. Also, valuable ironstone can be found in the Collier Brook section further downstream towards Howe Bridge village. To be allowed to do so, even back in the fourteenth century, would have involved documentation of some kind and that has never surfaced. In these very early days, it is probable that a yeoman landowner or one of his workmen would work any coal he found on his land and not declare it, hence the lack of an archive record. If the land belonged to the lord of the manor, he would control the taking of coal and driving of drainage soughs by including a clause in the lease and would take legal action if anyone transgressed.

In *Alder Fold* (*c.* 1890) by Atherton local historian T. H. Hope, the Duchy of Lancaster Pleadings is cited as mentioning coalmining in Atherton during Elizabethan times (1558-1603). It is recorded that the lord of the manor at Atherton sued his tenants, who had

resisted his sole right to 'getting, bankeing and takeing of coales'. Although he could not refer back to the original deeds citing this, Atherton still won his case. Deeds and other legal land and property agreements of the time often added on clauses excluding the right to delve (quarry) stone, to take coal and to drive drainage tunnels (soughs), often when there was no evidence that coal was even on site – best to put the clause in just in case!

John Lunn, in his *Atherton* (1971), mentions the use of coal, presumably mined locally, by an Atherton nail-maker way back in 1332 in a tax list he had studied. John did not feel the need to list his references or sources, as he wanted the work to be readable by all rather than be approached as an academic exercise. We can be fairly sure he mainly consulted the Lancashire Record Office, Preston, and Victorian printed transcriptions of early records carried out by the Historic Society of Lancashire and Cheshire, the Lancashire and Cheshire Antiquarian Society, the Chetham Society or the Historical Manuscripts Commission. As an academic in the old classical sense, he could read documents in obscure and older English 'court' hands or Latin and place them in their wider historical context.

In any other case, it might be dangerous to accept blindly the transcriptions he made of records, but I feel it fairly safe, in this case, to rely on John's work.

John suggests that the presence of coal outcrops across the borough made favourable the establishment of smithing and nail-making sites. This was one of the most ancient of Atherton's industries, stretching back at least to the late thirteenth century. The 2003 Gadbury excavations appear to have revealed a small-scale example of an early ironworking site. The very detailed report by UMAU has been digitised and can now be read online as a PDF document.

Right through to the late seventeenth century, coal did not take on prominence as a household fuel in Atherton. For the poorer classes, it would be regarded as a luxury. Before the days of coal deliveries in the township, there would be the cost of paying a collier to mine the coal plus the cost of the fuel itself and its transport. The collier himself would also be paying the lord of the manor a royalty if he were honest and declared his activities.

Wealthier yeoman landowners and nail-makers appear to have made use of coal more extensively than the poorer classes, as the will of George Withington in 1614 shows. His property lay at the far end of Bag Lane on the site of the present-day Railway pub. He is seen to have made use of both coal and cannel. Cannel was a choice coal not to be found in all mining districts due to it being formed from lake deposits; thin bands were occasionally found in conjunction with bituminous coal. In Atherton, the cannel section was only 4 inches thick and probably not worked at this time, so a likely alternative is that cannel from the Westhoughton or Hulton area was brought to Atherton and sold as a speciality. Very dense and burning cleanly with hardly any ash being produced, it burned like a candle, hence its name. Some people even burned slivers of it stuck in a lump of clay in the same way as candles. It could be carved and turned into trinkets, providing an interesting and lucrative sideline for a few individuals, especially in the eighteenth century in Wigan.

In 1615, we find that John Atherton, son of the lord of the manor, John Atherton, had decided to transfer some land near Old Hall Mill Lane beyond Howe Bridge to Thomas Ireland, one of the overseeing officials of his father's estate. Mentioned in the transfer is a sough (a mine drainage tunnel), and this may be the one that survived into

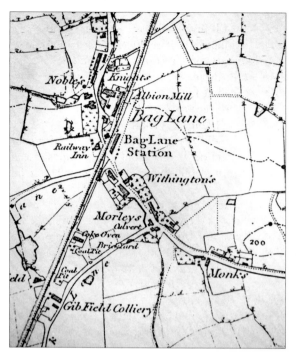

The 6-inch-to-a-mile 1849 first-edition Ordnance Survey showing Withington's farm and orchard on Bag Lane close to the railway line. If the seventeenth-century George Withington obtained his coal on his own land, then the Gibfield and Colliery Lane area may be one of the earliest mining sites in Atherton.

Part of plan NW356 held by the Coal Authority showing workings of the Trencherbone or Five Feet in the early 1840s beneath land near Withington's. Beneath the farm site is an area shown as 'Old Workings' and includes a shaft, marked with a ticked dash. This could be the shaft used by George Withington in the early seventeenth century.

the nineteenth century, draining into Old Hall Mill Brook. A year later, Thomas Ireland can be found granting a lease to Nicholas Withington that restricted him from mining activity. The landowner reserved the right alone to drive soughs, win coal and carry it away in carts. Soughs were very expensive to drive through rock, yet vital to allow mining to take place in areas where seams dipped at fairly steep angles.

In 1623, Simon Chow and his wife Alice were reported to the mayor of Wigan for regularly stealing locally dug peat turves from Lambert Vickar's stacks at Tyldesley Banks, an indication that coal was not as yet in widespread use. In 1631, regular coal user John Hope of Hope Fold (off the lower section of Bee Fold Lane, opposite the present-day school playing fields) felt it important enough to cite in his will that he owned a coal place or store.

Occasionally, individuals appear to have taken on coalmining as their main occupation long enough to be termed as colliers in their wills, an early example being John Thropp in 1665. At this time, we would find individual miners going underground into shallow ladder pits on demand to extract a few baskets of coal – freelance coalminers in a sense. Other, later examples of full-time colliers named as such are John Wadkinson in 1706 and John Morris in 1715. Not everyone was prepared to gain the knowledge to go underground and to work the coal safely or be aware how to support the workings, deal with the presence of methane gas or with the lack of oxygen. These men probably maintained a level of mystery about their work, which no doubt was lucrative!

In William Smith's will of 1672, a coal cart is itemised, showing he would visit a colliery and load up off the 'heap' as it was termed. Collieries at this time were land sale sites where people came to collect coal. Interestingly, for many years after Gibfield Colliery had closed in 1963, the site operated as a coal yard and was known as NCB Gibfield Landsale.

THE INDUSTRIAL REVOLUTION AND EXPANSION

The early eighteenth century saw many coal leases granted by the steward of the lord of the manor of Atherton. The industrial revolution, which originated partly in the manufacturing districts of Lancashire, was beginning its momentous journey, one that would have effects worldwide. The demand for coal, initially at local level at Atherton's smithies and nail works, was to increase greatly as more entrepreneurs decided that full-time coalmining was a worthwhile venture.

A series of short-lived leases have survived. From 1725 to 1728, coal is recorded as being worked by the executors of Paul Baxenden; by 1729, Henry Leyland is working the coal. From 1729 to 1733, Roger Leigh held a coal lease; from 1735 to 1748, William Gillibrand is recorded as mining coal. Robert Leigh worked the coal from 1748 to 1760.

As regards where these early mines may have been, the wide (nearly a mile across) outcrops of the Trencherbone (known as the Five Feet) from west of Schofield Lane (then known as Far Atherton) to Bag Lane, and the Black and White seam across Gibfield, Atherton and Chowbent near High Street were probably the sites of many shallow ladder pits or walk-in drifts. The geological survey map of 1929 actually indicates near Astley's Farm up Schofield Lane that the outcrop of the Trencherbone

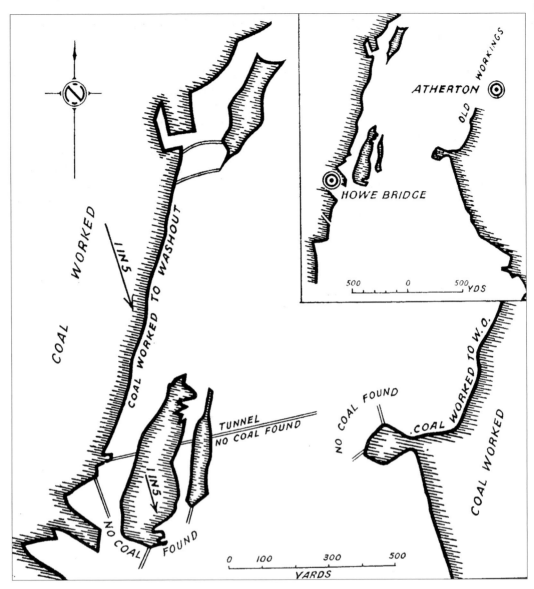

A large area of the highly prized Five Feet (or Trencherbone) seam was missing beneath Atherton due to ancient erosion after the formation of the coal measures, known as a 'washout'. This plan from the geological memoir for the Wigan District of 1938 (one-inch sheet 84) shows the boundary of the washout with trial tunnels searching for the seams reappearance.

had formerly been worked, so evidence still survived of those erratic early workings at the time of the survey.

The good-quality Black and White seam (the Great Mine), at 7 feet 10 inches in thickness, outcropping across the town centre, would cater for local needs for many generations without reaching depths where extensive pumping needed to be resorted to. Having the Five Feet or Trencherbone seam outcropping across the township was also a real bonus. Little were the early miners to know that this seam of coal was one of the finest ever mined in Britain, high in carbon and producing little ash, ideal for the many metal-working activities present in Atherton through the centuries and a real luxury to have on a household fire. Later miners were to be greatly disappointed as a large area of the Five Feet was found to be missing below Atherton having been eroded or 'washed out' millions of years ago. Compressed vegetation that would have become coal had been washed away by an ancient river.

The First Fletchers Arrive

From 1768 to 1775, the first of many generations of the Fletchers arrive. John Fletcher was a coal-merchant of Tong with Hough, Bolton, and with a Mr Fildes, sank two pits in 1769. These were probably close to the Gibfield site accessing the Five Feet seam. The shaft register held by the Coal Authority shows a number of shafts at Gibfield apart from the well-known Arley pit, upcast and Old Gib Pit, and according to Clement Fletcher, he remembers a mention of a pit at Gibfield in 1774.

The arrival of the Fletchers was timely as the new turnpike road from Bolton to Leigh, constructed from around 1775, would greatly improve transport and widen the sales radius of Atherton coal.

The days of short-term leases, which must have stifled capital investment in shaft sinking and surface plant, came to an end in 1776, when John Fletcher, and Thomas Guest, yeoman, of Bedford, Leigh, took out a ninety-nine-year lease of Atherton coal from the lord of the manor, Robert Vernon Atherton Gwillym (d. 1783). Robert Atherton must have sensed that the Fletchers had the expertise and ambition to work Atherton's coal efficiently and in a highly productive manner. Thomas Guest, the adjacent landowner to Robert Atherton, may have become involved through his links with Robert Atherton. The expense of capital investment in developing long-term colliery concerns must have come as a surprise to the Guests who, unlike the Fletchers, did not have extensive experience of coalmining. We find them leaving the partnership by 1804.

In 1777, an old Atherton diary (the diary of the lord of the manor, Robert Atherton, held in the Lilford Deposit DDLi at Lancashire Record Office, Preston) mentions a case of severe mining subsidence at Limbo (near Chowbent chapel). It gives us a fascinating insight into practices of the time and, coming so soon after the granting of coal leases, hints that management of the workings, and the working knowledge of the miners themselves, was occasionally not as good as it might have been, especially when working at shallow depths. It also shows that the lord of the manor took a personal interest in the activities of those holding mining leases from him, ensuring that they worked the coal efficiently and took responsibility for their actions.

The three diary entries Clement Fletcher transcribed for the Manchester Collieries' *Carbon* magazine in 1932 are so important that I felt they should be featured in their entirety here:

17th Nov (1777)
The ground under Limbo in Chowbent gave way and has brought down or damaged a great number of houses. Bromelow's and Peter Morris's to the Front of the Street entirely ruined [these are probably Black and White seam workings under Bolton Old

Road and High Street close to the outcrop or deeper Black and White seam workings]. Standbank's new house much damaged and several to the back poor cottages quite down. Sent over for Melling who came the next day, Nov 18th, and sent a collier down into the Pits who is clearly of opinion it was occasioned by the mismanagement of Fletcher and Fyldes which he describes in his examination in Mr Taylor's possession [James Taylor, steward to Robert Atherton].

26th Nov
Thos Guest came and said he had seen Mr Fletcher today who is ill at Manchester but hopes he shall be well enough to come over in ten days time. He is very sorry for the accident but will do anything in his power to repair the damage. Says he is sure the coals were got in a workmanlike manner and if it was to be done again does not know how it can be mended. He thinks nothing can be done at present as the inhabitants continue much alarmed, wrote to Melling desiring him to send some proper person over to examine whether the mischief may be kept from spreading and to quiet the minds of those who may be in no danger

11th December
Thomas Guest came over from Messrs Melling and Matthew Fletcher who have been for three days examining the mines. Brought with him a little sketch of a plan to show how the Bays of Coal lay about the buildings in Chew [Chow] Bent. The old colliers have done nothing more than is usually done in mines but they did not enough consider that they were working under houses instead of lands so that by cutting through the pillars and the loose earth giving away by change of weather etc., there was not enough for the ground above. The only way to have prevented this mischief and to stop it going any further must be to stop up with bricks the ways through the pillars. These roads through the pillars are to make the ways to the Eye [the walk-in drift entrance or shaft] nearer for the collier to bring the coals than is usually done. The examiner found all the places except where the fall was in pretty good Plight. They say Fyldes' house is in most danger.

This is a fascinating diary excerpt and shows us that the workings, probably in the Black and White seams, were very shallow under Chowbent and of the pillar-and-stall type, i.e., a network of roadways driven roughly at right angles to each other leaving blocks of unworked coal to support the roof. Very shallow workings often need more roof support than very deep ones as the bridging effect of the many layers of strata when deep below ground is not as effective at shallow depths. Often miners would leave a layer of coal in the roof to stop cratering, a practice still in use in British mines in the late twentieth century. In the early Atherton workings, leaving a layer of the Black and White seam at 7 feet 10 inches thick was an acceptable loss.

The excerpt shows us that the miners often cut roads through the large pillars to shorten the distance they had to haul the coal to the pit bottom and that this practice was normally safe. Occasionally, if this took place where the roof was poor or faulted, cratering could take place rapidly, working its way upwards, eventually affecting surface levels.

By 1787, Atherton's coal and mines were becoming known outside the township, with occasional visitors paying a call to view them. Dorning Rasbotham (1730-1791),

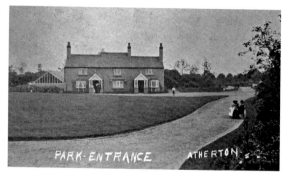

Cinnamon Place, Atherton Park, Bee Fold Lane seen in 1910. Converted and modernised for park staff by the time of the photo, these three cottages were originally at least of the very early nineteenth century in date and possibly housed miners who accessed the Black and White seam via a shaft a few yards behind. The Fletchers bought many cottages in Atherton to house their miners.

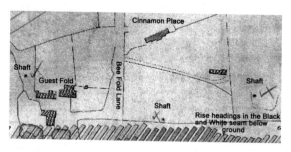

Five Feet workings of the early 1840s below Hamilton Street feature at the base of this part of plan NW356. Cinnamon Place cottages and nearby shaft; Guest Fold and its pit near the war memorial can also be seen. These shafts had accessed coal pre-1840. The presence of the Guest Fold shaft caused problems with plans to create a memorial park in 2008.

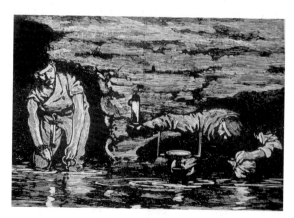

The 'dialler' or surveyor with his twin-sight compass in difficult conditions. The dial was made of brass to avoid influencing the needle reading. He would be called in occasionally to update the plan of the workings. The surveyor would set out the line of new roadways and assess the amount of coal recently extracted to enable royalties to be paid to Lord Lilford.

writer, antiquarian and artist, high sheriff of Lancashire, of Birch House, Farnworth, recorded:

Here is coal. Iron hath been formerly gotten, as appears from the cinders yet remaining [this could be the Cinder Hill close to the Botanical Gardens Club north of Tyldesley Old Road] and there are quarries of stone fit for building. The coal mines have long been worked. In the deepest part they do not lie more than 60 yards from the surface; they are freed from water by pumps, and are not liable to damps [accumulations of gas].

This shows us that the early workings, although shallow, were subject to the miner's old enemy, water, and being inclined at approximately one in five, had soon reached

depths approaching 60 yards. These workings were laid out over a wide area parallel to the outcrop of either the Five Feet seam near Gibfield or the Black and White nearer Howe Bridge. A number of shafts were sunk across these expanses of coal spaced out to make sure haulage distances below ground were not too great. Accessing the Black and White seam towards its eastern boundary stood Hillock Pit at the top of Tyldesley Road and Hamilton Street, where today's shop stands, then Morley Fold Pit close to the cottage, which still stands next to the playing fields, from there heading south-west to Cinnamon Pit close to today's park and the crossing of Bee Fold Lane and Hamilton Street. Onwards to Howe Bridge and the waterwheel-wound Molefield Pit at the top of Earl Street. These regularly spaced shafts would encourage natural ventilation due to surface height variations, air pressure and temperature differences. Heading from east to west, Hillock Pit surface was 200 feet above sea level, Morley Fold 165 feet, Cinnamon Pit 150 feet, and Molefield/Oak Pit (Howe Bridge) 120 feet.

Coal was worked from the level haulage roads to the rise, creating a network of 'bords' with level 'ends' or crossroads intersecting the panel of coal. The colliers then began to rework the pillars of coal, setting props close to the working face. As they advanced, the props were withdrawn behind them, allowing the roof to collapse. Working to the rise, gravity helped the collier get his basket or small tub of coal down to the level haulage road and the nearest shaft. He would attach his wooden tally stick to the basket so that the banksman on the surface knew who had produced the coal (hence the phrase 'keeping a tally'). Once a wide strip of coal from the eastern boundary to the western (predefined or a fault) had been worked, a series of deeper shafts were sunk to the base haulage level of the next wide strip to be removed.

Surveying was carried out on demand by 'diallers' (named after the miner's dial or large brass compass they used). They set out the layout of the double ventilation and haulage main roadways to ensure gradients were not too severe for the colliers or their drawers. The gradual inclination of these roads was designed so mine water would head off to a specific pumping shaft.

Late-eighteenth-century wooden miners' tally sticks of varying shapes. These were attached to baskets of coal below ground to 'keep a tally' of a miners output. Discovered at the Ravenhead opencast site, St Helens in 1994, similar ones to these would also have been used at the early Atherton pits. Each shape of tally was of a recognised form and had a distinct name across many coalfields.

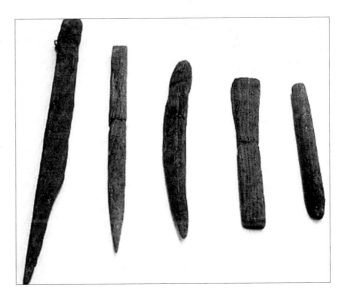

A New Lord of the Manor and Fletchers in Control

In 1783, lord of the manor Robert Atherton died. His daughter Miss Henrietta Maria Atherton of Atherton Hall married Thomas Powys, who in 1800, succeeded to the title of 2nd Lord Lilford. By marriage, Lilford acquired all the Atherton's estates and the rights to the coal and other minerals beneath them.

The state of the mines is audited in detail from 1800 in ledgers held at Manchester Local Studies Library and Archive. From these, we see that a day eye or drift mine was in use accessing an outcrop, its location not indicated. The best guess is that this was at the outcrop of the Five Feet or Trencherbone seam at Far Atherton (Colliery Lane off Schofield Lane), west of Gibfield. The numbers of men at work at the many small mines was small, ranging from ten to twenty-five. Named pits, such as Old Engine Pit and New Engine Pit, relate to pumping activity and the use of horse winding gins; others include Marsh pit, Little Pit, Sough Pit and Crabtree Pit, which was sited at Crabtree Brow, halfway down Crabtree Lane.

The use of gunpowder to blast down the coal or rock for 1801 amounted to £13 4s. This would have been needed in the shaft-sinking process, or to break down the rock-hard Trencherbone seam and the rock above it in the horse roads. In the 7-foot-10-inch-thick Black and White seam, its careful use could produce large coal, which brought the highest price; other seams may not have needed it. Horse-powered winding gins on the surface and the use of horses below ground is inferred in the ledgers through the concern for farming operations and the supply of wheat and oats.

The ledgers show that coal was being graded at the coalface using riddles (sieves), the small coal passing through being stowed in the waste area or disused roadways. When, in 1802, John Guest asked Thomas Livesey of Werneth Colliery, Oldham, how best to consider working the Black and White seam, which by then was known to lie to the south-west of Gibfield, it was decided that a 6 hp steam engine costing £600 to £650 should be installed to raise coal and water from a shaft depth of 70 yards. The alternative of installing a waterwheel-powered winder was discussed. The Fletchers were experienced in the use of waterpower at their Clifton mines and these were already in use at Oak Pit, opposite today's Howe Bridge School at the end of Earl Street.

The cost of driving a 1,000-yard-long tunnel from Gibfield to access the coal – £1200 to £1500 – was prohibitive. The coal accessible was estimated at 124,200 cubic yards (one cubic yard of coal is approximately 1 ton). Being 7 feet 10 inches thick, it was proposed that 66 per cent of the coal present would be worked, leaving behind roadside strips or pillars of coal, rock waste and small coal that had passed through the riddle.

Millions of tons of coal were left behind in these early Atherton workings and will probably never be reworked due to total closure of the roads, roof collapses, ventilation and water problems, and the fairly shallow depths at which they lie under property in Market Street and Hamilton Street.

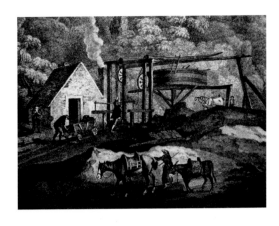

A typical horse-wound-gin pit of the late eighteenth century. Constructed of rough-hewn timbers, this could easily be dismantled and re-sited at a new shaft. Packhorses with frames to allow the carriage of large coal can be seen. The banksman watches out for the basket of coal arriving at the surface. The pits at Far Atherton up Schofield Lane would have looked similar to this back in the late eighteenth century and early nineteenth century.

A steam 'whim' gin of the early 1800s. A simple 'haystack' boiler next to the chimney supplied steam to the cast-iron open-top vertical cylinder. Linked to the wooden beam, this in turn was linked to the winding drum equipped with large-diameter hemp winding rope. The engineman also acted as banksman, stoker and salesman, occasionally leading to accidents as men were overwound into the pit headgear. It is recorded in the Children's Employment Commission of 1842 that boys as young as ten were to be found in charge of these engines in the Oldham area.

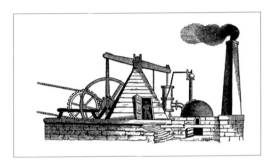

Ledgers from the early 1800s record the use of Atherton nails for sleeper attachment of rails, pit props costing 6d and, in one year alone, 646 yards of rail made for the pits at Taylor's Foundry. Candles were in use (the newly developed miner's lamps were not to be seen for another fifteen years), but at the accepted risk of igniting methane gas. The ledgers mention the cost of a 'damper'. This could have been a portable, hand-operated mechanical device like a fan to ventilate and dilute gassy areas. It may also have been a man who was prepared to enter gassy areas and flush out the gas or even ignite it on purpose: the 'fireman'.

Miners in this era had nerves of steel. They accepted on a daily basis that they could be injured travelling the shaft, travelling the roads, working the coal, and accepted future suffering from coal dust and years working in damp conditions. They also knew that their working lives were not that long, as life expectancy at this time was around thirty-five.

Miners expected to ignite gas a number of times in their working life. Usually, the gas was layered next to the roof and would light at the candle then shoot along the roof until exhausted. Larger quantities of gas (blowers), along with a good supply of fresh air, could create a substantial ignition or even a full-blown explosion with varying degrees of burns.

The coal was being wound to the surface in large wicker baskets (normally about 250 kg capacity) and distributed to local customers by early coal-merchants John Bowden and John Yates.

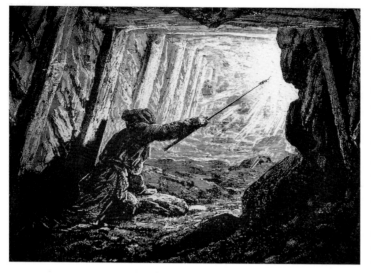

The 'fireman' clothed in damp rags igniting an accumulation of methane gas at the working place. The early miners must have had nerves of steel, being accustomed to regular ignitions of gas at their candles and receiving varying degrees of burns. The poor ventilation meant short-lived ignitions were more common than full-blown explosions igniting coal dust as well.

For generations, landowners had made sure it was written into mining leases that they received quotas of coal free. Entered into the Atherton ledger, we can see the occasional entry 'trust Lord Lilford' for the amount of coal and its value.

The fact that Atherton's coal industry was ahead of that in Tyldesley in development and probably coal quality is seen in Thomas Johnson and Mrs Froggatt of Astley, both major Tyldesley and Astley landowners, using Atherton coal at this time.

It appears that the profits of the Atherton collieries were not exorbitant and occasionally a loss is shown as 'short'. Occasional yet necessary mining work in the form of shaft sinking or driving soughs would require substantial capital investment. Taxes, such as brick duty, land tax and horse duty, were also taking their toll.

RALPH FLETCHER CLAMPS DOWN

An insight into some of the colliers' characters and emerging attitudes at the Atherton pits at this time is seen in this newly discovered archive entry held in the North of England Institute of Mining Engineers, Newcastle upon Tyne:

London September 8 1802
A few days ago, five men employed in the coal-pits at Atherton, in Lancashire, were duly convicted before the magistrates at the sessions in Bolton, of having entered into a combination to obtain from their employers an advance of wages; for which offence two of them were committed to the castle of Lancaster for three months, and the other three to the house of correction at Preston for two months.

The Combination Act of 1799 prohibited trade unions and collective bargaining by British workers. An additional act had been passed in 1800. None other than the men's employer Ralph Fletcher (known as the Scourge of the Radicals) sat as a magistrate himself at Manchester and so was guaranteed the outcome he required!

Ralph Fletcher (1758-1832), son of John Fletcher (I). A
Manchester magistrate along with fellow coal owner William
Hulton of Hulton Park and Colonel of the Bolton Militia,
Ralph already had mining interests in Little Lever when he
moved to Atherton in 1803. Living at The Hollins, Haulgh,
near Bolton, he rode to Atherton on horseback each day. He
was a strong-willed man who stood for no trouble from his
workforce. His opposition to the formation of early unions
or combinations earned him the nickname 'the Scourge of the
Radicals'.

As mentioned earlier, the Guest partnership, for various reasons, was destined to be
short lived. By 1803, John Guest, son of Thomas Guest, had sold his share to Ralph
Fletcher of Bolton, son of John Fletcher after suffering financial difficulties. 1804 saw
two partners, John and Ralph Fletcher, in control of the collieries. There was no holding
the Fletchers now as the demand for coal dramatically increased.

The accounts submitted to Lord Lilford for 1804 give a fascinating, detailed view of
the technology in use at the time along with crucial dates for certain pits being sunk
or closing. Selecting but a few of many important entries, we find that on 3 July the
miners were bought 'liquor' for their work in setting up a new horse gin at Green's
(possibly near and to the east of Atherton Central Station). Usually the beer was drunk
at Isaac's Wheatsheaf inn on Market Street. Interestingly, the present-day Wheatsheaf
was recently renamed Old Isaac's. The men who had to timber up collapsed workings of
Jerry Hodson's Coxes Pit, which had damaged the turnpike road (near today's Central
Station bridge), were paid 3s 6d. The timber came from nearby Green Hall Farm and
Coxes Farm. Men were brought in to fill in the gaping hole in the road.

Contractors specialising in repairing roads below ground feature in the accounts. During
the striking up of a deal with Ramsdale & Co. to clean the Middle Bank level (a main haulage
road) at Crabtree Pit, the cost of liquor at the meeting is shown as 4s 8d. The work itself was
charged at 1s 3d per yard, the contractors were also to survey ('dial') parts of Jerry Hodson's
pit at Coxes. At this time, coal output and royalties due was assessed by measuring the length
of new coal roads (or headings) of a standard cross-section driven since the last survey.

Interestingly, the Hulton Coal Sough (drainage tunnel) is mentioned, being inspected
by Ralph Fletcher and Mr Hulton of Hulton Hall. A major feat of engineering, this
drained mines within the Hulton estate and exited near Mill Dam Brook a few hundred
yards north of Central Station.

Shaft sinking was in progress in late 1804. Oak planks for shaft curbing rings are
mentioned along with lime for mortar when bricking the shaft. A temporary sinking
rope 60 yards long was bought for £3 from Ladyshore Colliery near Farnworth, also
operated by the Fletchers.

The Fletchers and John Langshaw (their cousin) are mentioned in a survey book as
surveying collieries at Clifton near Swinton owned by cousin Matthew Fletcher. Various

branches of the Fletcher dynasty appear to have shared their expertise between mines at Atherton, Bolton, Breightmet, Clifton and Denton.

By 1821, Lord Lilford, who was not, it seems, one for major personal involvement in mining activities, decided it was easier to sit back and allow the Fletchers to take total control of mining the coal while taking 250 tons of free coal a year for himself. In the lease held at the Lancashire Record Office, we see that the Fletchers were expected to produce at least 2,000 pit loads a year. A load was an old term for coal capacity, very variable in size from a 'cart load' to a varied number of baskets. For this period, the closest I can get is that approximately one load might be twenty-four baskets, each of five hundredweights of 112 lbs. The expected output was thus around 12,000 tons.

By 1795, the Bridgewater Canal had been extended from Worsley to Leigh to link up with the Wigan branch of the Leeds and Liverpool Canal providing through-navigation between Lancashire and Cheshire and beyond. Atherton's first railway was to be one of the world's earliest, the Bolton to Leigh line of 1828-9. The Fletchers saw the potential and sank the 10-foot-diameter Old Gib Pit at Gibfield alongside the line in 1829. The marketing and potential customer base of Atherton's coal was enlarged enormously. Seams such as the Five Feet or Trencherbone became known far afield for their quality.

John Fletcher must have been an amazingly energetic and motivated man. In 1834, we find him also acting as agent (overall production and marketing manager) for the Fletchers' collieries at Clifton near Swinton.

STREET LIGHTING

Some of Atherton's ratepayers were becoming so proud of their vibrant town that they attempted to secure coal gas lighting for its streets under the Lighting Act of 1837. This was opposed locally and once more in 1844, arriving a few years later. The First Edition OS map of 1849 shows the gasworks and its single gasometer in place off Water Street near Atherton parish church. The Fletcher brothers and their cousin Langshaw were in total control by 1840 when the firm of John Fletcher & Others was founded. In partnership were John Fletcher, Ralph Fletcher II, James Pearson Fletcher and John Langshaw.

Now was to begin the period of major investment in the collieries, allied with relatively assured geological knowledge of the district. The old mining method of 'widework' was not going to be suitable to access the coal at great depth. Sinking a new series of deeper shafts would be far too expensive. The answer would be to sink new deep shafts, which would be the main access, winding, ventilation and pumping sites, at three points of a triangle: Howe Bridge Colliery to the west, Gibfield Colliery to the north-east, and Chanters Colliery to the east, the shafts having insets at the level of the seams worked. In the sinking process, Fletcher & Others gained a detailed insight into the geological structure of the coalfield and could then make long-term mining planning decisions.

Investment on the Howe Bridge site came in 1850 with the completion of the sinking of the winding shaft known as the Victoria Pit down to the Six Feet seam (Rams) at a shallow 150 yards. The company posted a rare loss of £1,406 11s 1d between 1848 and 1850, reflecting the heavy cost of shaft sinking and associated works required in establishing a new colliery. By 1861, the Volunteer shaft had also been sunk, to become the ventilation shaft. Yet another Fletcher, James, brother of John, was the company general manager at this time.

1862, the First Geological Survey of Atherton

A geological map of the Atherton coalfield (and adjacent areas) was first published in 1862 by pioneer coal geologist Edward Hull. He and his colleagues would attend the meetings of Manchester Geological Society and must have spoken to the Fletchers, their surveyors and officials, as well as the old miners in the district. Their experiences at the small-scale ladder pits, horse-gin- and waterwheel-wound pits around Howe Bridge, Schofield Lane and Atherton would be invaluable for providing information on strata passed through by shafts, seams worked, major recognisable fossil horizons and large geological faults.

It's interesting to think that some of these old miners would have been born in the late eighteenth century, the grandsons of the first miners employed by the Fletchers when their first lease was taken out from the lord of the manor, Atherton, in 1768.

Along with walking the fields, studying coal seam outcrops in the numerous brooks or in rock 'delfs' or quarries, Hull and his team built up a fairly accurate picture of the district's geology. He overlaid his findings onto the superbly detailed, first-edition, 6-inch-to-a-mile Ordnance Survey plan of 1849. This gives us our first insight into the level of geological knowledge of the town at that time and also indicates shaft locations. It was a start, albeit with unavoidable projection of outcrops and conjecture regarding fault locations.

This addition of geological information to the first-edition OS map of 1849 makes sense today of the seemingly haphazard siting of shafts by those working the coal in Atherton in the late eighteenth century. With this knowledge of the geological layout of the district and its huge potential, the early Fletcher and Langshaw partnership could now plan to expand their mining activities in Atherton. Five years later, in 1867, the coal lease with Lord Lilford was renewed with the same four partners.

Fletcher Burrows & Company

Liverpool-based businessman Abraham Burrows first became involved in the marketing and shipping of Atherton coal around the early 1850s. By 1859, he was named on a small booklet entitled *Black Diamond* as the Chief Agent for Sales and eventually moved closer to Atherton, living at Hindley Hall. He commented with surprise on the loyalty customers had for particular types of coal. Users of coal could vary from a household requiring a clean-burning, high-carbon, low-ash product, such as the Trencherbone (known locally at the time as the Five Feet), to a small brickyard that was happy burning lower-grade, high-ash coals such as the Crombouke and Brassey.

A period of major investment began in 1871 with the sinking of the winding shaft at Gibfield further down to the Arley seam at just short of 400 yards. It had originally only been sunk to the Five Feet seam at 100 yards.

In 1872, James Pearson Fletcher died, John Fletcher (II) retired and Abraham Burrows became a partner along with Ralph Fletcher junior.

LOVERS LANE EXPLOSION

As the pace of mining increased, it was inevitable that an incident of some size would eventually take place. Twenty-seven men and boys died at Lovers Lane Colliery on Thursday 28 March 1872, adjacent to Howe Bridge Colliery, after a methane explosion resulting from poor levels of ventilation. The figure could have been far greater when disaster statistics at other collieries in the coalfield are compared.

After the Lovers Lane disaster, investment in colliery ventilation plants was made. Lovers Lane was approaching the end of its working life and safer working and ventilation methods would have to suffice, but at Gibfield Colliery, a mechanical ventilation fan was installed in 1873 (later to be superseded in 1891 by a 13-foot-diameter Schiele fan, which was capable of removing 170,000 cubic feet of air a minute).

In 1874, Major John Langshaw had retired, the partners then being Ralph Fletcher, Abraham Burrows and Ralph Fletcher Junior. The company was then named Fletcher Burrows & Company, a name to become memorable in the annals of British coalmining history.

As with the Fletchers, the Burrows family followed careers in the coal industry. Abraham's son John (1854-1917) was very much the energetic, 'hands-on' mining engineer, overseeing the period where the Atherton collieries total yearly output regularly exceeded 500,000 tons. After J. S. Burrows retirement, Leonard Fletcher took over the reigns until he died in 1916.

Clement Fletcher (1876-1965), son of Ralph Fletcher Junior, had become a director of the company by 1901. Clement fully immersed himself in the business and technology of mining as well as the life and history of the community and was a much-liked man. He was the driving force behind the establishment of the Lancashire and Cheshire Coal Owners Howe Bridge Mines Rescue Station, Lovers Lane, in 1908. This was the first central rescue station serving a number of collieries in Britain. The setting up of the station was timely as, two years later, on 21 December 1910, at the Pretoria Pit, Over Hulton, disaster occurred. This was Britain's third-worst mining disaster; 344 men and boys died, including twenty-three men and boys from Atherton. Howe Bridge trained rescue teams played important roles in the rescue and clean-up operations. Colliery management from the Atherton pits were to be found on site and below ground as well.

Clement promoted the introduction of the first pithead baths in Britain. These had been in use on the continent for many years. After a successful trial installation in the old winding-engine house at Howe Bridge Colliery opened on 1 August 1913, the Gibfield baths (which still exist today) opened on 13 September 1913. Clement was a keen advocate of safe working practices and the energy behind the success of *Carbon* magazine. His historical articles show how proud he was of his family's long connection with the industry in Atherton.

The industry in Atherton was not without its occasional industrial-relations problems, from the men demanding a wage advance in 1802, to the arrival in 1881 of mobs of miners from nearby districts objecting to some men working and the subsequent Battle of Howe Bridge. The long strike of 1893, the Minimum Wage strike of 1912, the strikes of 1921 and 1926 drew varying levels of support from Atherton's miners, who in general, had safe workplaces, decent housing, and community facilities. The company accepted their miners were part of greater regional organisations and made sure they did not suffer too harshly during periods of industrial unrest.

END OF AN ERA: THE DEMISE OF FLETCHER BURROWS & CO.

The poor state of the coal industry post 1921 and 1926 led to government proposals and legislation under the Coal Mines Act of 1930 to improve efficiency, partly by amalgamations of small companies. In advance of this, the directors of Atherton Collieries held negotiations with five coal companies leading to the formation of Manchester Collieries Ltd by April 1929. The new company comprised: Fletcher Burrows & Co. Ltd, Andrew Knowles & Sons Ltd (Agecroft Colliery, Clifton Hall Colliery, Wheatsheaf Colliery, Newtown Colliery, Pendleton Colliery), Bridgewater Collieries & Wharves Ltd (Sandhole Colliery, Mosley Common Colliery, Ashtons Field Colliery, Brackley Colliery), Astley & Tyldesley Collieries Ltd (St George's, Gin Pit, Nook Pit), Pilkington Colliery Co. (Astley Green Colliery) and John Speakman & Sons Ltd (Bedford Colliery).

The trading slump of the late 1920s led to the Coal Mines Act of 1930 and moves to amalgamate colliery companies with improved marketing and operating efficiency. On 1 July 1936 an even more effective marketing and sales amalgamation across the Lancashire and Cheshire coalfields created Lancashire Associated Collieries.

In the lead up to the expected nationalisation, a major technical report was carried

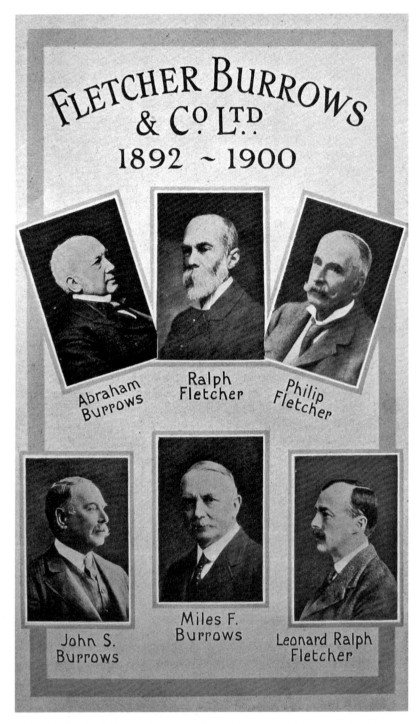

The mix of marketing and mining excellence brought together to form Fletcher Burrows & Co. Ltd, one of the most highly regarded mining companies in Britain at the time.

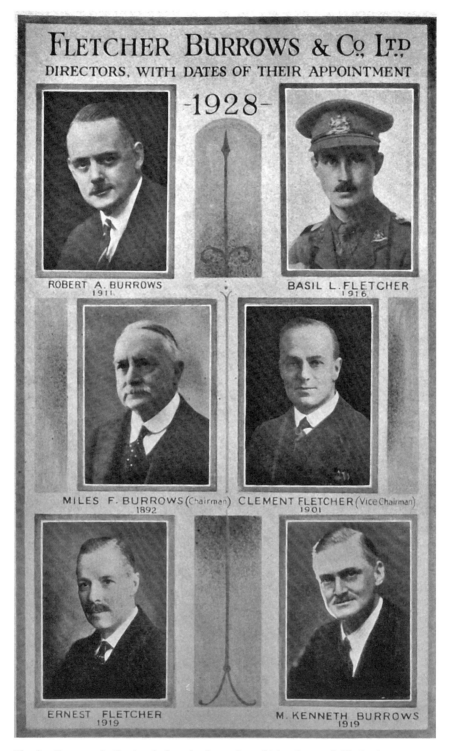

Fletcher Burrows & Co. just before the formation of Manchester Collieries in 1929.

out by Manchester Collieries Ltd planning district layouts for their remaining coal reserves. The plans show for Howe Bridge, Gibfield and Chanters that reserves in the best seams were dwindling and that relatively small short-life panels of coal among old workings were to be worked. These plans show how millions of tons of coal were lost in the form of barriers in seams between pre-nationalisation collieries and beneath highly populated areas and mills. The coal panels amounting to hundreds of thousands of tons left beneath the former Laburnum Mills near Central Station are there to this day.

National Coal Board 1947

On 3 November 1919, a speaker to Atherton Collieries Joint Association Debating Society spoke on the 'Nationalisation of the Mines' to a workforce and management audience, showing how open-minded Fletcher Burrows could be! Britain's industrial greatness was founded and maintained on coal. The sorry state of the industry after the 1921 and 1926 strikes, followed by the trade depression of the 1930s, and then the serious shortages of fuel during the Second World War meant that government action was needed to safeguard the industry. After the nationalisation of the coal industry in January 1947, Atherton's miners thought major changes for the better would take place; not so, an old, retired Atherton colliery surveyor told me. Many of the officials of the newly formed National Coal Board were drawn from the former private coal companies and little changed. What he did tell me as a former senior surveyor was that enormous amounts were paid out in compensation to some private coal companies. Manchester Collieries Ltd was compensated for coal they never really intended to work, yet had proposed to do so in their Technical Report.

After 1 January 1947, the Atherton collieries became part of the new Manchester Area, Sub Area 3, along with Deane Colliery, Bolton; Cleworth Hall Colliery, Tyldesley; and Bedford Colliery, Leigh. After 1 July 1951, the Atherton pits were transferred to the No.2 Wigan Sub Area.

The initially wartime measure of opencast coal working to boost production as men were lost to the forces, carried on after 1945. Small output sites at Atherton were named after nearby farms: 'Shams' west of Shakerley Lane in 1947-8, 'Crab Fold' west of Bee Fold Lane from 1956 to 1958, and 'Bee Fold' east of the lane in 1958-9.

With nationalisation came gradual efficiency improvements through mechanisation; even the small Howe Bridge site came under attention. Its winding capacity was boosted by the introduction of skip winding in 1955. An old Howe Bridge colliery man told me that in the colliery's final days more winding of the huge kettle up and down the shaft for the pit-bottom men took place than of coal. He said the men at the pit bottom could shout loud enough up the shallow 150-yard shaft to be heard.

The end of deep mining in Atherton was already on the horizon as the Clean Air Act 1956 arrived, designed to reduce sulphur dioxide pollution after the deadly smogs of the early 1950s. Competing fuels, electricity, oil and gas, increasingly vied for the household and industrial market share.

Further NCB reorganisation came on 1 January 1961 as Chanters and Gibfield became part of the new East Lancashire Area. The Atherton coal reserves were dwindling; coal quality had been a problem since the early 1950s as the poorer coal seams, the Yard, for example, were now being worked. The heydays of the famous Trencherbone, Rams and Arley seams in full production were over and all the pits were now over a century old.

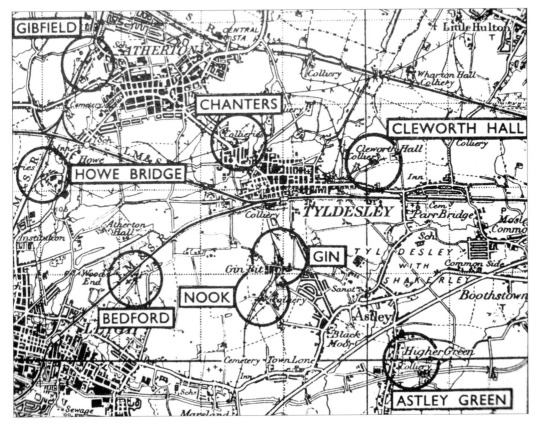

After the coal industry was nationalised in January 1947 an annual *Guide to the Coalfields* was published listing every colliery and private mine, detailing the size of the workforce and type of coal produced. The first edition of 1948 shows the location of the Atherton collieries along with neighbouring mines.

Howe Bridge (sunk *c.* 1849) closed on 11 September 1959, Gibfield (active 1774, Old Gib Pit sunk 1829) ceased production on 30 August 1963, and Chanters (sunk *c.* 1850) closed on 25 June 1966. On closure, men headed off to larger nearby collieries such as Mosley Common (closed 1968), Astley Green (closed 1970), Bickershaw, Parsonage and Golborne (all closed 1992) and Parkside, which closed in 1993.

Since 1966, the only mining to have taken place in Atherton was the 1981-2 opencast site down Bee Fold Lane to the east, and west of Millers Lane.

The photographic record that survives of mining in Atherton is one of the most extensive of any colliery concern in the Lancashire coalfield, and here, for the first time, nearly all of those images can be seen.

The Collieries

THE EARLY DAYS; HEATH ROBINSON'S THOUGHTS

In late 1921, the artist Heath Robinson visited Atherton Collieries. They commissioned him to put his experiences down on paper with a view to producing an illustrated calendar. This was to be in two sizes, A3 for businesses and guests and an A4 version for the company's workforce and others. The originals eventually went into Manchester Collieries hands, on display in their Cross Street, Manchester head office. On nationalisation in 1947, the National Coal Board added them to their mining art collection; British Coal and the Coal Authority following.

That Fletcher Burrows & Co. felt this was a worthwhile idea shows something of their attitude and ability to see the funny side of coalmining; I personally feel Clement Fletcher was behind the idea, having a strong sense of humour.

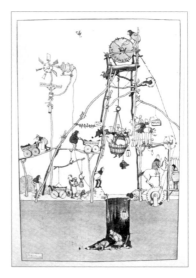

Above left: The 1922 Heath Robinson calendar cover with one of Atherton's old-time miners preparing to be lowered down a windlass shaft.

Above right: The wooden headgear at Howe Bridge Colliery may have inspired Heath Robinson to carry out one of his humorous transformations. Here, the pit is being sunk with Atherton wagons taking waste away. Have a good, detailed look at the image to really see the genius of the artist.

Above left: The pit is well established now and look at the shape Heath Robinson has given to the workings, like a giant £1, so perhaps he had his own ideas on capitalism exploiting the poor miners!

Above right: A view in the screening and picking shed with meticulous care and attention being paid to coal quality. The tiered-screen sheds at Gibfield probably inspired this vision.

Left: 'A Busy Day in the Washery' is the title of this image with every lump of coal being washed by hand and then hung up on the line to dry.

Gibfield Colliery

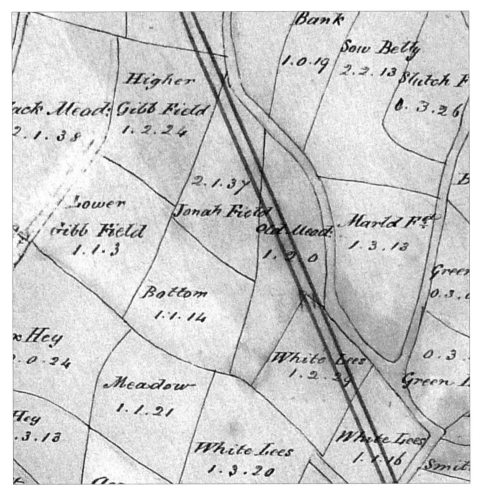

The earliest plan of the Gibfield site, held in the Lilford deposit at the Lancashire Record Office. The later addition on the plan of the proposed Bolton to Leigh Railway line (First Act of Parliament 1825, completed by 1829) is shown on this estate rental survey of around 1770. Every field has a name, its acreage shown. At the bottom, the line crosses the future Wigan Road. Higher up, we see the Higher Gibb Field and Lower Gibb Field from which the pit of 1829 took its name. The colliery was sited in the space created where the future Coal Pit Lane meets the proposed line twice.

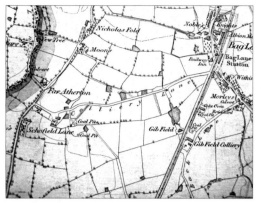

Far Atherton, Schofield Lane on the 1849 6-inch first-edition OS map. Horse gins were in use here in the late eighteenth century along with beam pumping equipment with brass working barrels (non-return valves). Two more earlier shafts existed farther west at the entrance to the lane to Astley's farm on the lower left edge of the map.

Five Feet workings beneath Old Gib Pit. The varying shades indicated different periods of extraction, allowing assessment of royalties due to Lord Lilford. The upper section was mined in 1840-41. The double roads crossing the plan are ventilation and haulage levels where horses would be used to get tubs to the shaft bottom. The vertical spacing between the levels was approximately fifty yards. The double roads are cross-linked roughly every ten yards with cut-through roads. These would have had coarse cloth 'brattice' sheeting hanging across to stop short circuits in ventilation.

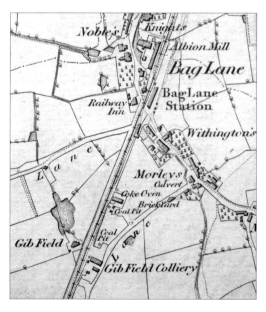

The superbly detailed 6-inch-to-a-mile first-edition Ordnance Survey. This was surveyed between 1845-7 and published in August 1849. We see the single-line railway, three shafts (the coal authority shaft register shows ten shafts on site) a coke oven and a brickyard. Also on the plan is Gibfield Cottage where engineer Edward Ormerod was to base his business. The first edition plan allows you to try and visualise the landscape of the time, still quite a rural one.

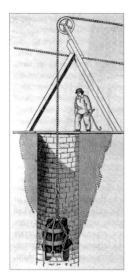

Above left: Simple shafts of the early 1800s really were just holes in the ground, and occasionally, it was recorded across most coalfields that 'a stranger was found at the bottom of the pit'. Ellen Smith was born at Gibfield in 1846. She reminisced in *Carbon* magazine in February 1922 of a horse falling into the shaft at Gibfield that only had doors around it. The horse fell onto the first ladder stage and was successfully hauled out. The banksman has a hook in his hand to draw the rope towards him to bank the coal sledge. Note the large lump coal is held in place with iron hoops.

Above right: Stone rail mounting blocks of the single line Bolton to Leigh Railway of 1828-9, photographed at Gibfield in the early 1960s. Made into a wall after removal, these are possibly still on site, overgrown. The line was surveyed by Robert Daglish and George Stephenson from 1824

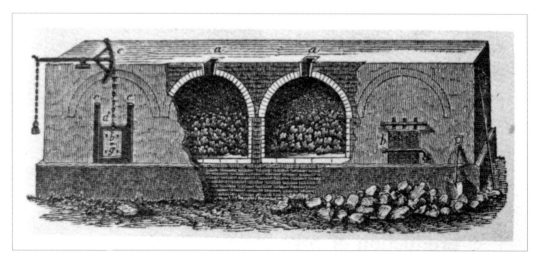

A simple coke oven of the type in use at Gibfield at the time of the first-edition OS map of 1849. The Five Feet or Trencherbone was a good 'caking' coal (ability to be converted into coke) below 3 inches in diameter. The busy metalworking industries in Atherton would no doubt make very good use of their only local supplier.

1836	Crabtree Tubs Coal	Gibfield Tubs Coal	Lovers Lane Tubs Coal	Oak Pit Tubs Coal
apr 9	443	3287	754	840
23	690	4148	1094	1057
may 7	494	3306	839	769
21	641	3679	896	807
June 4	611	3135	339	770
18	402	3573	690	925
July 2	560	3153	502	740
	3921	24281	5114	5908

Lord Lilford's rental account for 1836 shows Gibfield raising about 500 tons per week. Its steam winding engine gave it the advantage over the old waterwheel-wound Oak Pit, the probable horse-gin pit of Lovers Lane and the ladder pit at Crabtree.

The only image in existence of Old Gib Pit engine house and headgear alongside the Bolton Leigh line, taken on 29 May 1947. These are not the original winding arrangements and may date from the 1870s when the colliery surface was redeveloped with the sinking of the Arley Pit. Old Gib Pit was 10 feet in diameter, sunk to the Five Feet at nearly 100 yards and later to the Arley seam at 388 yards. The shaft was later furnished with three steel guide ropes and one single-deck cage, hence the single pulley wheel. The steam winding engine was a twin cylinder horizontal of 18 inches by 48 inches, maker unknown. The winding drum was plain of 8 feet 6 inches diameter by 5 feet 9 inches wide. At the time of the photograph, the wooden headgear was still in use. The brick casing of the fan evasee (outlet chamber) can be seen alongside the banking level along with the fan engine house.

On the site of the former Bolton to Leigh, later LMSR line an ex-LNWR Super D 0-8-0 locomotive heads off initially through Bag Lane station then up the steep 1 in 18 incline to Chequerbent. The locomotive is hauling former private-owner wagons from Stanton Ironworks Ltd, Sheepbridge Coal & Iron Co. Ltd, and Tredegar Collieries.

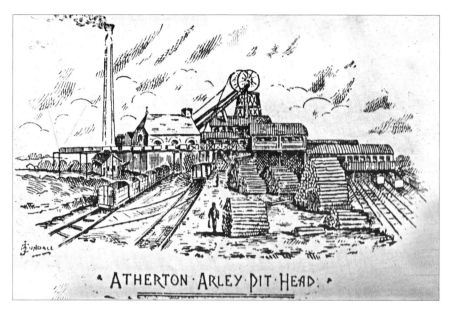

The Bedford Colliery, Leigh, explosion of 13 August 1886, where thirty-eight men and boys died was described in the *Sunday Chronicle*, Manchester. One of their journalists visited Gibfield Colliery, resulting in the publication of an illustrated booklet 'An Order For The Pit'. Giving us the earliest view of the pit looking south, we see the Arley Pit engine house, tub circuit and screens above the Bolton to Leigh line, also pit prop stacks. (Artist J. A. Cundall.)

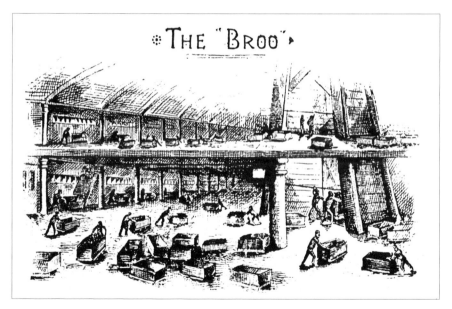

'The Broo' or pit brow. A busy day for the surface hands with double decking of tubs in operation. Tubs were pushed to the tipplers on the left, the coal then dropped down to the screen room below to be dressed, 'cleaned' of dirt and graded. The workers had the luxury of a roof over their heads rather than working out in the open.

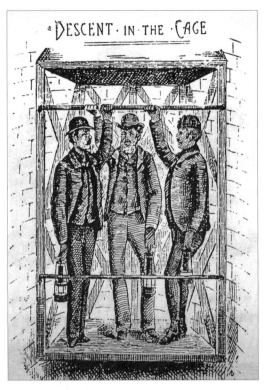

Left: Visitors travelling the 411-yard, 15-feet-diameter Arley shaft. Anyone who has worked in mining would be none too keen to travel in such an open cage, especially if the men have had to squeeze in! Guide ropes are not shown but would have been in use by 1886, as would an Ormerod detaching hook linking the cage to the winding rope.

Below: A collier breaks the Arley coal down with his hand pick. The drawer fills the coal into a tub to be pushed away to the main haulage road. The Arley was the finest coal in the Lancashire Coalfield, 83 per cent carbon and leaving only 1.1 per cent ash after burning. 4 feet thick at Gibfield, the height was ideal for the collier to kneel while working and setting props.

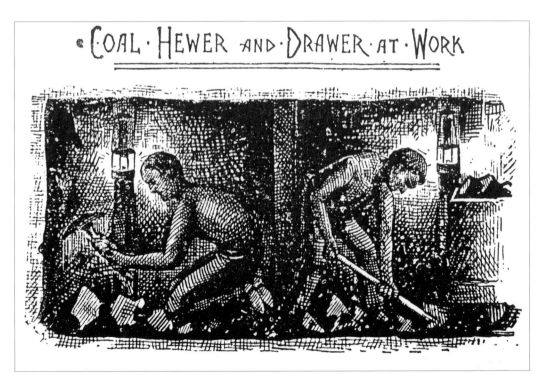

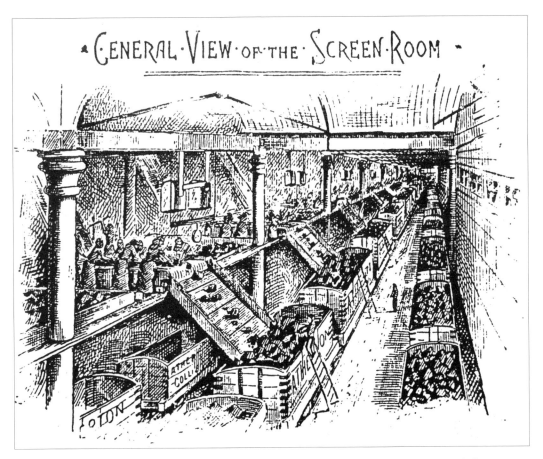

Six picking belts were in use in the screen shed at this time with around six women per belt. Mainline dumb buffer wagons of approximately eight-ton capacity are being individually loaded and levelled with specific coal types and sizes, all of which brought different prices. Hidden beneath the foreground chute is a wagon painted as 'Atherton Collieries' as well as the familiar 'Atherton' wagons.

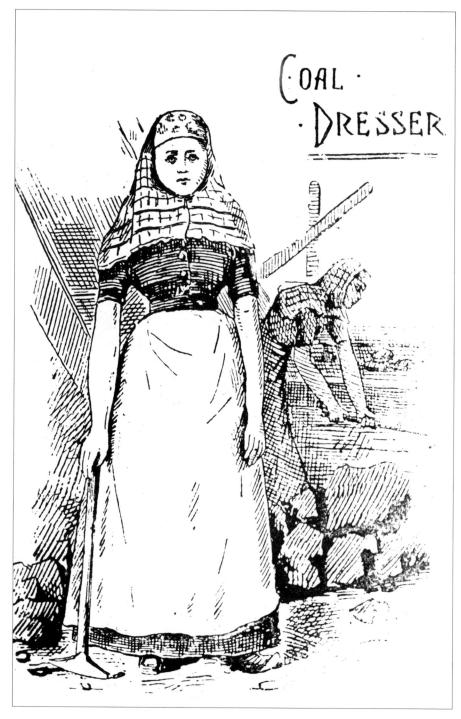

A coal dresser in the screen shed. Her trimming pick is short bladed similar to heavy stone picks used below ground. She would break down irregular-shaped lump coal and trim off any dirt bands.

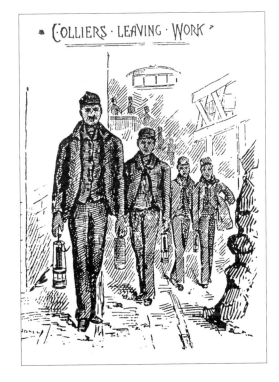

The well-fed lamp examiner dismantling and
cleaning Marsaut- and Clanny-type miners
safety oil lamps. The colliery also allowed
officials to use Davy and Mueseler lamps,
each with varying characteristics when in the
presence of gas. The examiner is checking the
internal gauze for enlarged apertures, refilling
lamps with light oil and replacing the lead rivet
which hindered tampering below ground.

Colliers and boys leaving work after a
gruelling nine-and-a-half-hour shift. In
1886, only 1 per cent of British mines used
mechanised coal cutting. Colliers earned
approximately 25s for a five-day week,
stonemen 26s, drawers 21s, a fireman or
deputy 29s. No pit baths yet in 1886 at
Gibfield, but public ones were available at
Howe Bridge village.

51

Coalmining in Atherton brought with it locally generated innovation and technical advances of national importance through its history. One innovation was to have a worldwide influence. Edward Ormerod (1834-1894) was the son of George, who worked for John Fletcher & Others as chief engineer at the time of the sinking of the Volunteer Pit at Howe Bridge in 1861-2. George died in 1862 with Edward succeeding him in his post. An overwind took place at the Volunteer Pit, the cage smashing through the wooden pit headgear then the engine house roof. This may have inspired Edward to design a safety device that would fit between the end of the winding rope and the cage to detach the winding rope and leave the cage safely suspended in the headgear.

By 1865, Edward was based at Gibfield, living in cottages opposite the colliery. In 1867, he patented his detaching hook, after fighting off a lawsuit over possible infringement of design. The time came to test the hook. Edward walked across to Gibfield and set the hook up. A large audience gathered including John Fletcher, Ralph and James Fletcher, Major Langshaw, colliery officials and members of the public.

A man volunteered to go in the cage but Edward refused and insisted he went in alone. Edward told the engineer to wind him down the shaft 20 yards. A few moments later, he was wound up at full steam and the detaching hook worked. Manufacturing began in 1868. The business was very successful and Edward retired from the colliery company in 1874, but died aged only sixty in 1894. The 10,000th hook was dispatched on 9 November 1954, and by a strange coincidence, the customer was NCB Gibfield Colliery. Hooks are still made today for a vastly diminished worldwide mining industry, although no Ormerods are involved. Examples can be seen at the Astley Green Colliery museum.

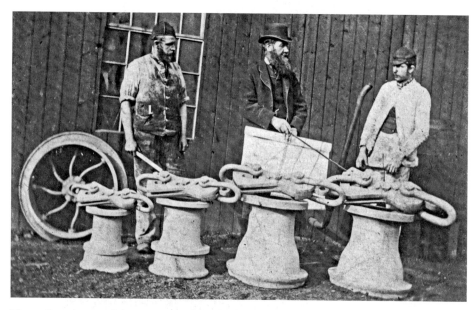

The earliest photograph in existence related to Atherton's coal industry. Edward Ormerod displaying his range of detaching hooks and bells around the mid-1880s. The bell was mounted in the pit headgear, the winding rope passed through it then was linked to the top of the cage via the detaching hook. It is fascinating to think that, being born in 1834, Edward probably witnessed all the major sinkings in Atherton along with the remains of the late-eighteenth-century coal industry.

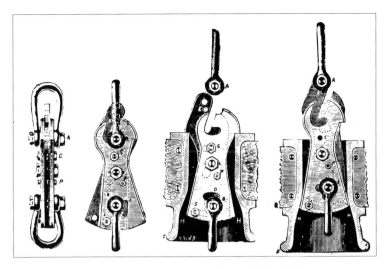

Ormerod's hook in action. The third image shows the hook after passing through the bell in the headgear, its lower plates closed by the constriction. Their closure has made the top section open out to rest on the bell-top edge. As it did, the winding rope was released. The rope could later be reattached temporarily as per the fourth image. These are made today of Manganese steel.

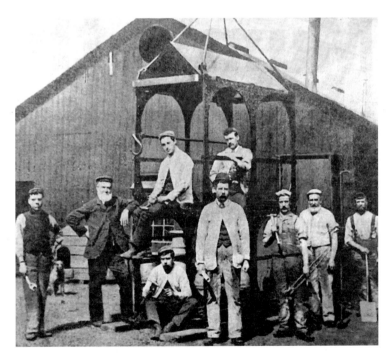

Edward Ormerod and another invention, his patented safety cage, the safety aspect being that, in case of a winding rope breakage, the cage clamped onto the guide ropes in the shaft. This very rarely happened in reality and sales were not to be as extensive as for the detaching hook.

Left: Edward Ormerod died in 1894 and is commemorated in Atherton cemetery by this superbly sculpted memorial stone. Living very close to this as a young lad and being puzzled as to what it was, little did I know that my life would be safeguarded in future by the object carved on that stone! When I worked at Coventry Colliery, men called it 'the Butterfly Hook'.

Below: A series of photographs were taken in 1905 of surface scenes at the Atherton Collieries. Lantern slides were produced from them, probably for management to use in presentations, also a set of postcards. Gibfield had its own wagon shop for repairs and refurbishments. Here the staff give an idea of the scale of a refurbished four-plank dumb buffer coal wagon.

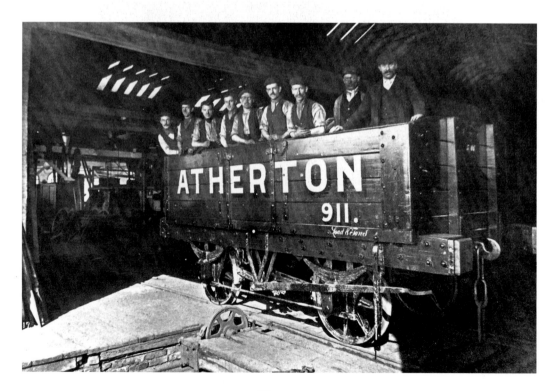

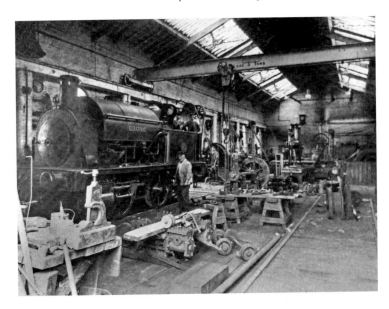

1905 series, the engineering shops. Loco *Electric* was said to have been made at Gibfield during the 1893 miners lockout over pay disparity, which lasted sixteen weeks. The 0-4-0 locomotive was designed to fit in the tunnel near Leigh station to Bedford canal basin. Sold in 1927 to the Netherseal Colliery Company near Burton-on-Trent.

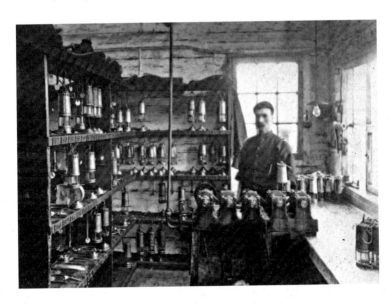

1905 series, the lamp room (as visited back in 1886). Naylors of Wigan Marsaut A and A1 oil lamps on the racks. In evidence are miners' clay pipes, metal tally discs, a 'snap' or food tin and oil-container bases of lamps. The lamp man stands next to powered drives for gauze cleaning, polishing and the fast unscrewing of internal flanges. The lamp room was reorganised in 1909 to house electric lamps. A separate one was later set up to accept Gray-Sussmann No. 4 and No. 5 and Oldham 'bottle' electric lamps.

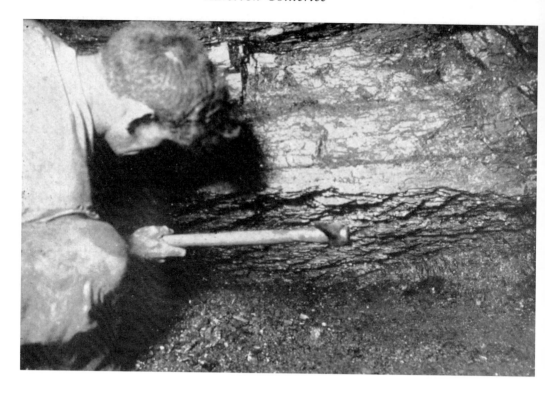

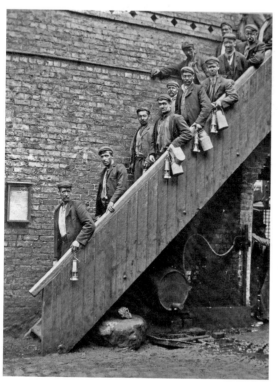

Above: A collier at the coalface. Although not taken at Atherton, this photograph shows a collier undercutting the seam prior to bringing the coal down, either by pick or by using explosives. Hours spent leaning sideways in low light strained the eye muscles leading to disabling nystagmus, an uncontrollable oscillating of the eyeballs. Men would be off work for weeks, even months. Not all employers were sympathetic; many were suspicious of new cases.

Left: 1905 series, end of shift. Men leave the Arley Pit bank. No protective headwear, just flat caps. Note the large water cans and snap tins. The baths at Gibfield arrived eight years after this photo so they went home 'in the black'. Many headed off to Howe Bridge via the miners' path through the Hawthorn trees, which is still there today next to the large housing development.

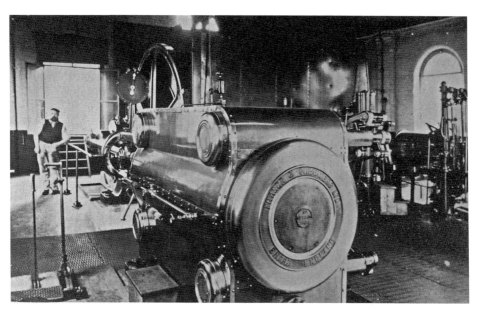

1905 series, the proud winding-engine man alongside the Arley Pit winding engine made by Fraser & Chalmers of Erith, Kent, in 1904. 26-inch-diameter cylinders by 4-foot-6-inch stroke, parallel drum 16 feet diameter with balance rope beneath the cage. Double-deck cages with simultaneous decking. The 15-foot-diameter shaft was sunk in 1872 to 400 yards. From 1904 to 1913, extensive modernisation was carried out at the pit.

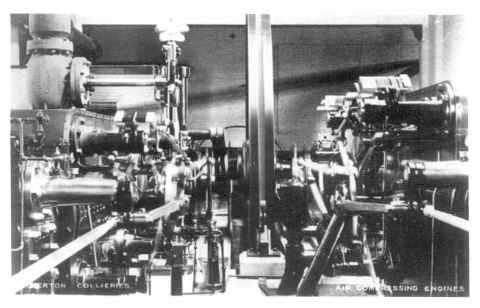

1905 series, postcard. Recently installed Fraser & Chalmers air compressors. Cross compound horizontal engines with two-stage air cylinders delivering 4000 cubic feet per minute at 65 pounds per square inch. Compressed air was needed both above and below ground for pumps, coal cutters, haulage engines and tools, in later times, even for driving lights with built-in turbines.

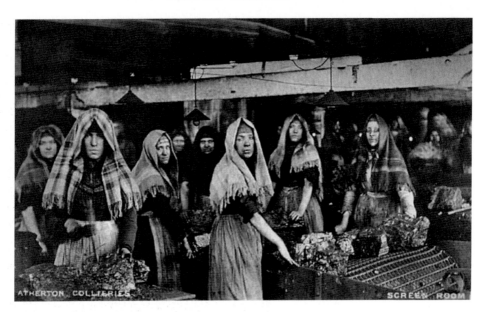

1905 series. Pit-brow women were used more in Lancashire than the other coalfields and were famous enough for postcards like this to be produced from around 1904. At Gibfield, six hand tub tipplers sent coal down to six 'bar' conveyors, three of which were for large coal or 'cobs', the others for smaller coal or 'burgy'. The women separated out any dirt, dressed and trimmed the coal.

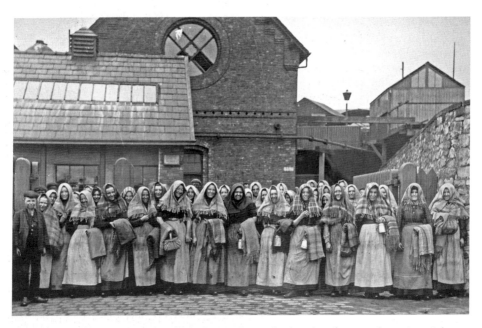

1905 series. A happy group of pit-brow lasses, due to the fact that the second row is mainly men with shawls over their heads to pad out the numbers! A visitor to Gibfield in 1886 stated, 'The women, robust and well developed in physique, look as healthy and as happy as any class of labouring women I have ever met', and I am sure he was totally correct in his observation.

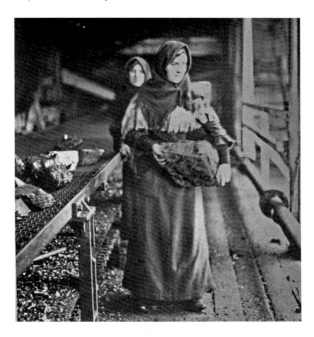

1905 series. Pit-brow women regularly had to handle lumps of coal like this on the screens. National protests against them working (by miners) in 1863, and later by social and political reformers in 1886 and 1887, led to a deputation by the women in their working clothes to parliament in May 1887. They successfully halted legislative changes. In 1911, they had to do this again and once more were successful. From then on, they were left alone, gradually being phased out by 1972.

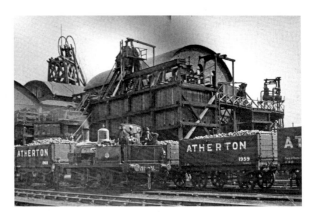

1905 series. Gibfield Arley's old, wooden headgear of 1872 was replaced shortly after the photograph was taken. The coal washery close to the wagons was erected in 1892; one of the first in Britain. The locomotive is 0-4-0 *Atherton* of 1867, built by Hawthorns of Leith. Of low height to travel the tunnel near Leigh station to Bedford canal basin, it was scrapped in 1952.

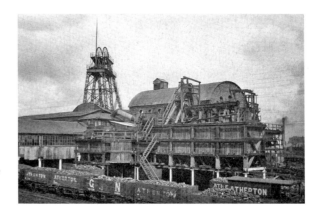

A similar viewpoint to the 1905 photograph, this time taken around 1919. The old, wooden pit headgear has gone but little else has changed. The wooden 'heapstead' washery and screen shed structure remains. The presence of a Great Northern Railway wagon in the sidings shows how far afield Gibfield's customers could be.

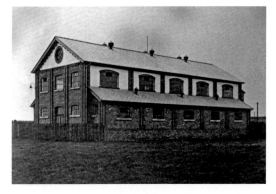

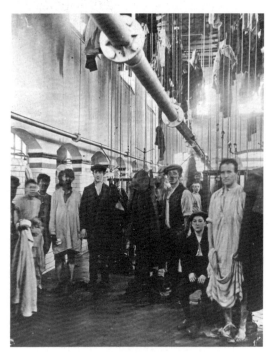

Left: Through the initiative of Clement Fletcher, who visited collieries on the Continent to see examples of best practice, a trial miners' baths was set up at Victoria Pit Howe Bridge in August 1913. By November, 130 of the 155 men at the pit were using it. Probably due to the immediate success of this, the baths at Gibfield were built and opened by 15 September of the same year. Looking at the timescales involved, it must have already been in construction at the same time as the Howe Bridge trial.

The installation (although termed a trial in records) at Howe Bridge could be called the first miners' pit-head baths in Britain, but as it is designated as such, the building at Gibfield is regarded as the first and amazingly still stands today, although slightly altered by recent users.

The installation of these baths at the expense of Fletcher Burrows & Co. drew wide acclaim from the Women's Labour League and the Miners' Federation of Great Britain, and not least, from the men's wives who could now hang the tin bath up. Baths at Chanters Colliery followed in 1914.

Middle: The dressing area near the entrance to the baths with what look to be the men's dirty clothes hanging up on the ropes.

Below left: On entering the baths, the men and boys hooked up their dirty clothes onto their personal ropes running round pulleys up in the roof and took a clean shirt from their clean group. Retaining their dirty shirts for decency, they then headed off to the cubicles, later putting their dirty shirt on the rope. Their mothers' bathing and cleaning workload, especially in a house where the father and boys all worked at the pit, was now much lessened.

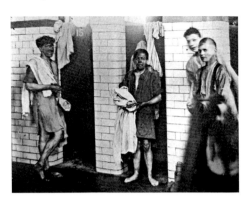

Lads at the cubicles. No doubt they were very proud now to be able to walk home clean and tidy rather than 'in the black'. Not all men welcomed the baths and preferred the privacy of their own homes. Even in the 1980's at Bickershaw Colliery I remember some men preferring to shower at home.

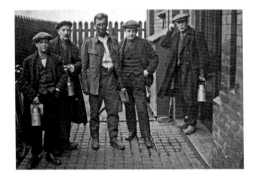

'Before and After' was the caption to this photograph taken at the baths' entrance.

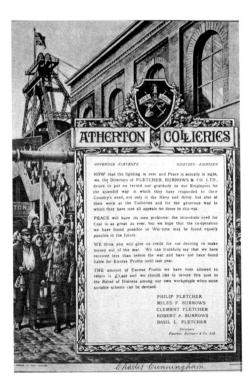

In 1913, British coal output peaked at 287 million tons. With the end of the First World War, Fletcher Burrows & Co. decided they would donate the excess profits they had been allowed to retain during the war (when the industry had been nationalised) to the relief of distress amongst the workforce. They issued this certificate to the workforce to explain their actions. During the First World War, coal had been in great demand to fuel steel and iron works working overtime for the war effort. After the war, the industry was in a sorry state, over-manned and uncompetitive, with electricity and oil increasingly entering the realm of power supply. The Royal Commission on the Coal Industry in 1919 led to calls from politicians for permanent nationalisation of the industry to modernise it and safeguard its future.

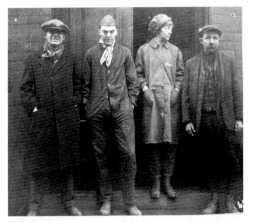

Professor T. H. Pear, MA, BSc, was a prominent academic from the Department of Psychology, Manchester University. Among his studies was one on industrial psychology and public health. Here, on 3 March 1921, he visits Gibfield with his wife. From the left, Professor Pear; F. N. Siddall, colliery manager; Mrs Pear; and A. Stanley, colliery undermanager. Note the undermanager's clothing. He is wearing two jackets and a waistcoat, plus a scarf. He would be used to travelling the workings and hanging up his clothes at various points as it became hotter or harder to travel!

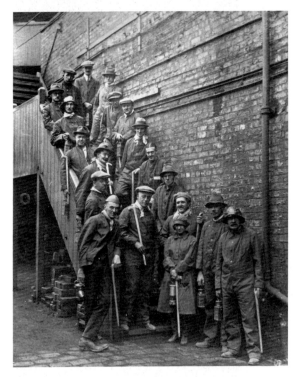

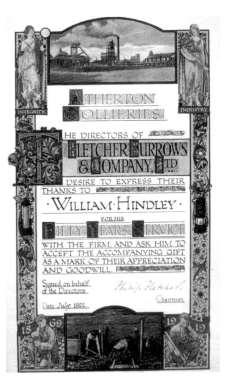

Above left: By 1920, foreign coal was undercutting British in terms of price. Mine owners tried to cut miners' wages in 1921; a strike was called on 31 March. Coal rationing came in on 3 April. The strike lasted eighty-nine days. Members of the press from as far afield as Liverpool to Oldham came to see an example of best practice at Gibfield Arley on 20 October 1921. Bottom left, with the old style miner's leather skull cap and portable Oldham bull's-eye-lens hand lamp is Mr F. N. Siddall, the colliery manager.

Above right: Elaborate long-service certificate for William Hindley after fifty years of service, July 1922. At the top is Gibfield Arley No. 1 pit from Wigan Rd. On the left edge, a Davy-type oil lamp; on the right, an example of a post-First World War lamp. Personally signed by Philip Fletcher. Designed by eminent Manchester calligrapher Alan Tabor.

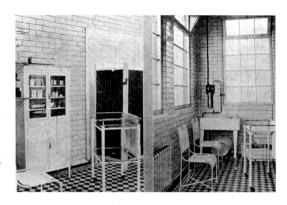

A new first-aid post close to the lamp room
was installed at Gibfield in March 1925.
In the first twelve weeks, 318 injuries were
treated and 584 injuries re-dressed. Looking
rather harsh today the facilities were state
of the art for the time.

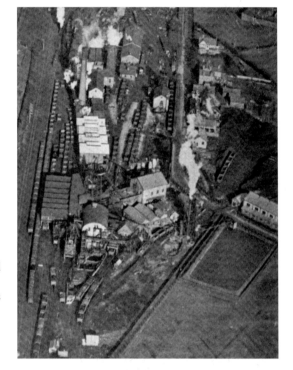

Aerial photography was very popular in
the early 1920s. Gibfield was photographed
in 1925 by Imperial Aerial Co. We can see
Coal Pit Lane on the right next to the baths
and water lodge. The Arley pit, screens
and washery are to the left alongside the
railway. Officials housing is at the far end
of the lane on the right.

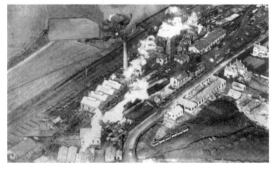

Another angle in 1925 shows the offices
next to No. 2 pit, middle right. The site
of Gibfield Cottage is top left where the
Ormerods' business was based. Next to the
cottage is Ormerods' Lodge where I wasted
many hours in the early 1960s trying to
catch tiny perch.

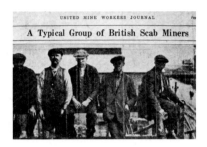

UNITED MINE WORKERS JOURNAL

A Typical Group of British Scab Miners

The 1926 Strike

The British coalmining industry suffered an economic crisis in 1925, caused by various factors; the First World War: the heavy domestic use of coal in the war meant that rich seams were depleted. Britain exported less coal in the war than it would have done in peacetime, allowing other countries to fill the gap. The United States, Poland and Germany and their strong coal industries benefited.

There were several main reasons for the sorry state of the industry. Productivity, which was at its lowest ebb. Output per man had fallen to just 199 tons in 1920-24, from 247 tons in the four years before the war, and a peak of 310 tons in the early 1880s. Total coal output had been falling since 1914.

The fall in prices resulting from the 1925 Dawes Plan that, among other things, allowed Germany to re-enter the international coal market by exporting 'free coal' to France and Italy as part of their reparations for the First World War.

The reintroduction of the Gold Standard in 1925 by Winston Churchill. This made the British pound too strong for effective exporting to take place from Britain, and also (because of the economic processes involved in maintaining a strong currency) raised interest rates, damaging businesses.

Mine owners wanted to normalise profits even during times of economic instability. This often took the form of wage reductions for miners. Coupled with the prospect of longer working hours, the industry was thrown into disarray. Mine owners announced that their intention was to reduce miners' wages, the Miners' Federation of Great Britain rejected the terms: 'Not a penny off the pay, not a second on the day' and the Trades Union Council responded to this news by promising to support the miners in their dispute. The Conservative government under Stanley Baldwin intervened, stating that they would provide a nine-month subsidy to maintain the miners' wages and that a Royal Commission under the chairmanship of Sir Herbert Samuel would look into the problems of the mining industry. The subsidy gave the mine owners and the government time to prepare for the expected major labour dispute.

The Samuel Commission published its report in March 1926. It recognised that the industry needed to be reorganised but rejected the suggestion of nationalisation. The report also recommended that the government subsidy should be withdrawn and that the miners' wages should be reduced to save the industry's profitability.

After the Samuel Commission's report, the mine owners published new terms of employment for all miners. These included an extension of the seven-hour working day, district wage agreements, and a reduction in wages. Depending on a number of factors, the wages would be cut by between 10 per cent and 25 per cent. The mine owners declared that if the miners did not accept the new terms then, from the first day of May, they would be locked out of the pits. The Miners' Federation of Great Britain refused the wage reduction and regional negotiation.

An American mineworkers union publication *The United Mine Workers Journal* sent a journalist to Britain to assess the scale of the 1926 strike. They were told of men working at Atherton and managed to photograph some of them at Gibfield. No doubt the men had no idea in what context their photograph would be used!

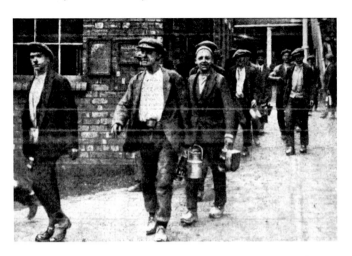

Right: The Atherton miners were some of the very first in the country to return to work after the long strike, having been reluctant to join in the first place. They had caring and flexible employers who lived among them and genuinely had their best interests at heart in many respects. During the strike, Fletcher Burrows doubled the strike pay of their employees and kept them busy with sports events and other activities. Here, the men have finished their first shift after the strike, which had lasted from 4 May to 29 September.

Middle: Long-service employees 1926. Atherton Collieries employees were very loyal to the company and amassed very long service records. Certificates were presented along with a retirement gift. All these men were over sixty years of age, the oldest being sixty-eight. All had started work with the company fifty years earlier and were carrying on doing so.

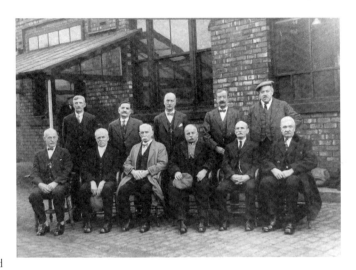

Below right: Although not taken at Gibfield, this shot of the late 1920s shows how shot holes were drilled at the face using a ratchet drill. The drill post was unscrewed to tighten it to the roof and floor. The deputy, wearing just a flat cap, is testing for gas emerging from the shot hole. The collapsed waste area or 'gob' is to the right.

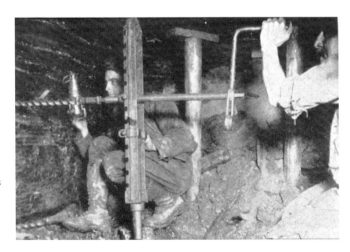

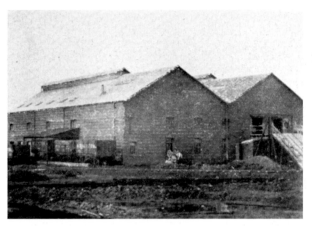

Bricks had been made in Atherton for centuries by the time of Gadbury brickworks' construction in 1925. The Lilford estate plan of around 1770 shows 'Brick Kiln Field' very close to the site. Fletcher Burrows & Co. were now building houses once more near Carr Bank Street and Gloucester Street, giving their workforce the opportunity to buy them on reasonable terms. To have a brickworks of their own made good sense.

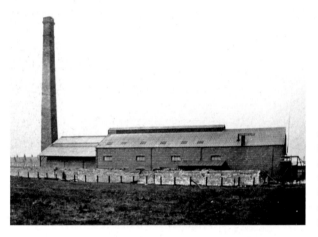

Gadbury brickworks photographed in Manchester Collieries days around the early 1930s. Tens of thousands of bricks await delivery in the stock yard. Little was to change on site until its closure around 1966, three years after the colliery.

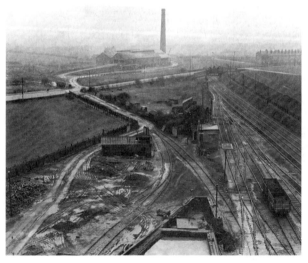

Early 1960s view from No. 1 Arley pit headgear towards Wigan Road and Gadbury brickworks, now a new housing development. The 2003 reclamation project and excavations uncovered remains of the Wigan to Manchester Roman road close to the site of the chimney. Note the disused line from the pit to the brickworks alongside today's car scrap yard.

Gadbury Atherton brick
dating back to about the
late 1920s to late 1930s.
Most housing in Atherton
after the late '20s was
probably built using these.
Not in the same league as
the hard-faced, weather-
resistant Accrington but
not prone to cracking or
flaking.

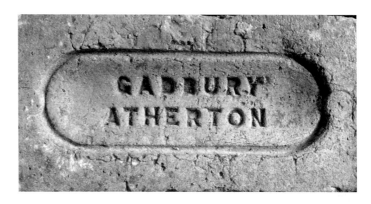

Pressed common NCB
Gadbury brick of the late
1940s to early 1960s. In
1962, the works was listed
as producing 2 7/8-inch
pressed commons, pressed
selected commons and
sand-faced facings. The
works had closed by 1966.

Extremely rare Gibfield
Arley Mine Pit lamp-
room tally for an electric
lamp. These were for the
Gray-Sussmann No. 4
rechargeable 'bottle'-type
lamps. These could give out
around two candlepower
but weighed around 7 lbs.

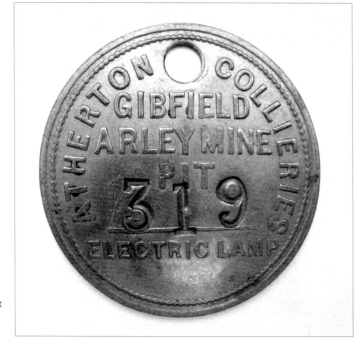

Ellis Houghton and Ben Stirrett, Gibfield, loco men circa late 1920s. These men had the opportunity to drive two locomotives built in 1861 and 1867 by Hawthorns of Leith, at the time thought to be the oldest working locomotives in Britain. The locomotive behind them is probably Hunslet Engine Co. Ltd *Colonel*, purchased in 1927.

Charabanc trip from Gibfield to Blackpool in the 1920s. These motor coaches, usually open-topped, were once common in Britain, especially popular for sight-seeing or works outings to the country or the seaside. The French *char à bancs* means 'carriage with wooden benches' and the journey to Blackpool and back must have been memorable to say the least!

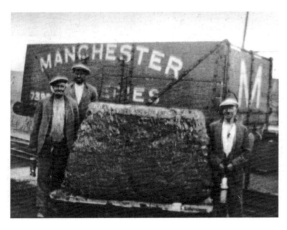

Occasionally colliery companies would extract a large lump of coal for trade fairs and industrial displays. If the colliery was producing from a famous seam such as the Arley, Trencherbone or Cannel, that would be chosen. To work around this lump of about a ton, probably of Arley coal, and get it from the coalface to surface without breakage was quite a feat, hence the men involved being photographed.

Right: Wooden-bodied model Manchester Collieries coal wagon circa mid-1930s by Leeds Model Company. The firm made O-gauge wooden coaches and wagons with lithographed sides and a very large range of model locomotives.

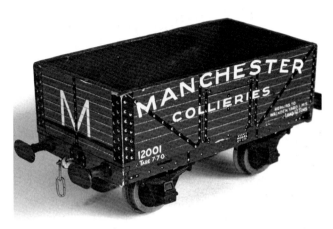

Middle: On 2 March 1932, the Duke of York, later King George VI, visited Gibfield Colliery as president of the Industrial Welfare Society. He was a good friend of Robert Burrows through his work with young people. Robert was chairman of the Manchester Lads Club and the South East Lancashire Scouts Association. On a three-day visit to the north-west, the Duke stayed at Robert's house at Bonis Hall, Prestbury. Here the Duke is being led around Gibfield by Joseph Ramsden, chairman of Manchester Collieries and formerly managing director of Tyldesley Coal Co. On the far right is Robert Burrows.

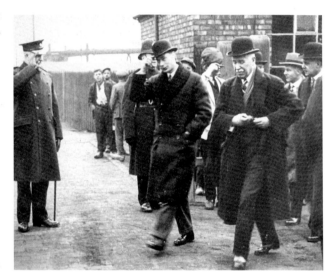

Below right: The Duke walks alongside men who had just come up the Arley shaft at Gibfield. He was genuinely interested in the operations of the colliery and chatted with the engine winder and screen women. He was treated to Lancashire hot pot at the Briarcroft Club and apparently had a detailed knowledge of the delicacy and the right way to prepare it. The Duke strived through his Boys Clubs to break down the barriers between boys in privileged society and those in the workings classes. What greater contrast could you possibly have as he walks next to the miner in his pit dirt staring in awe at him.

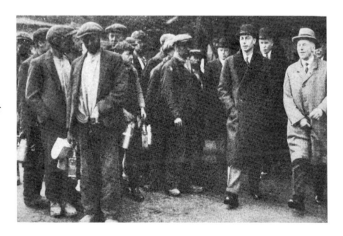

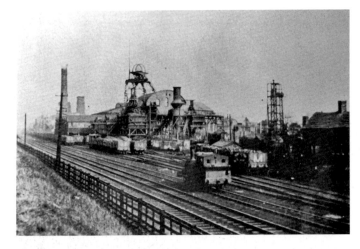

Around 1935 and loco *Lilford* is at work. Built by the Hunslet Engine Co. of Leeds in 1892. *Lilford* had been used at Hemsworth Colliery in South Yorkshire before coming to Atherton. It was scrapped at Gin Pit workshops in 1938.

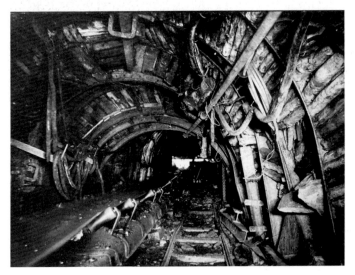

Probably taken for the Lancashire & Cheshire Safety in Mines Committee (LCSMC). Here, the problem is roof pressure following the contours of the arches and rising up in the roadway centre known as 'floor lift'. Pit prop wood is being used between the arches as a much stronger alternative to lagging boards.

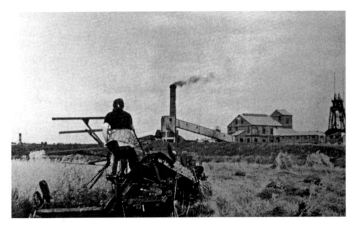

View from the west. The late 1930s caption states that the land from which the harvest is being cut was formerly colliery spoil, on which a layer of top soil had been placed. No doubt the complex binding machine is a product of Harrison McGregor & Guest of Leigh.

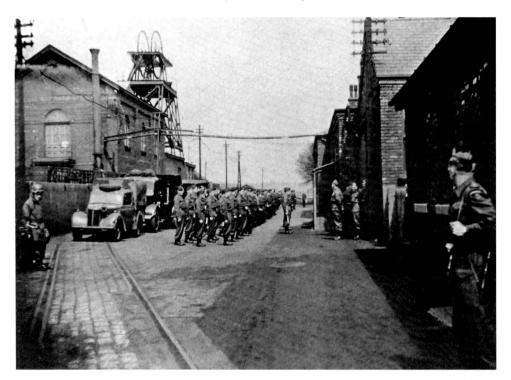

The Second World War ARP (air-raid precautions) exercises circa 1940 on Coal Pit Lane in front of the colliery offices. No. 2 upcast shaft is in the background. Mr Boyle was the local colliery ARP instructor of the team, which formed part of a greater Manchester Collieries scheme. A motorcycle dispatch rider stands on the left.

1946 Five Quarters seam proposed layouts by Manchester Collieries (for the period 1946 to 1960). Fairly extensive reserves beyond the 36-foot Eckersley Fold fault to the south of Gibfield. In actuality, Chanters was to work the seam and Gibfield would concentrate on the Plodder.

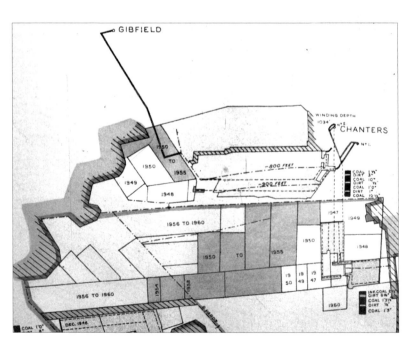

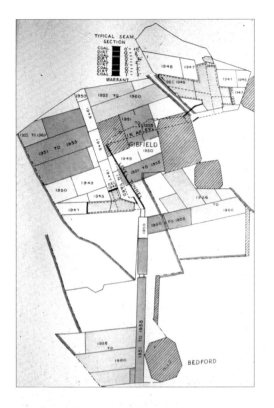

Above left: Plodder seam proposed layouts around the Gibfield site and reaching out to the shaft pillars at Bedford Colliery. A very dirty seam and, being one of the lower seams, gassy, as was found on 6 March 1957 when Chanters suffered its explosion, eight men dying.

Above right: Ormerod Safety Detaching Hooks (Gibfield) advertisement from the 1948 *Guide to the Coalfields*. This was the first issue after nationalisation in January 1947. Ormerod hooks were to become the most widely used at the NCB collieries. The image shows a hook resting on the bell after detaching of the winding rope.

Below left: Winding-engine man at the Arley pit on 29 May 1947. Nationalisation is a few months old, 577 men were working below ground and 177 on the surface. Winders had to be reliable, steady and trusted types and even had their own union. The curtain shields him from the heat of the cylinder.

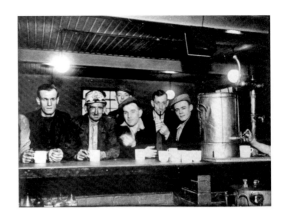

In the canteen, 29 May 1947. Colliery canteens have always been good value with their subsidised charges; occasionally, I used to have two dinners at Coventry Colliery. Here the men are probably wondering what all the nationalisation fuss was about. Their working routine and six-day week was just the same as ever.

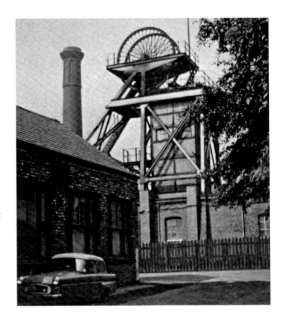

No. 2 pit from near to the offices. Looking at the Mk E or F Bond Minicar, the date of the photograph could be around 1957-60. No. 2 pit was never meant to be the main winding shaft. Sunk to the Arley seam between 1904 and 1914 and 399 yards deep, the shaft was mainly for winding men and materials.

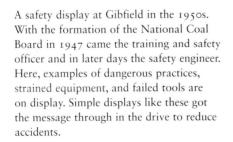

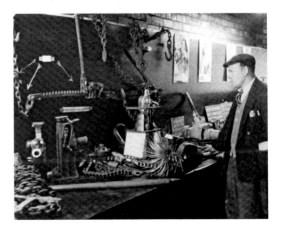

A safety display at Gibfield in the 1950s. With the formation of the National Coal Board in 1947 came the training and safety officer and in later days the safety engineer. Here, examples of dangerous practices, strained equipment, and failed tools are on display. Simple displays like these got the message through in the drive to reduce accidents.

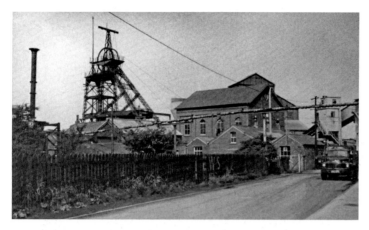

Late-1950s entrance view from the Coal Pit Lane Wigan Road corner. The fence next to the water lodge still has EWS painted on it (Emergency Water Supply), harking back to the days of the air-raid precautions team at Gibfield.

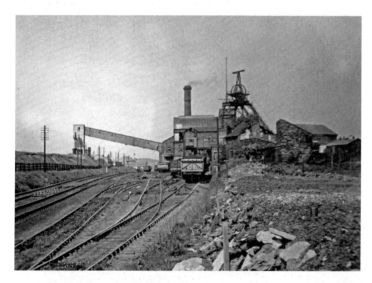

An interesting view alongside the former LMSR railway on 27 May 1957. After nationalisation of the railways in 1948, the use of the line declined and closure (apart from excursion trains) came in May 1952. The Bag Lane to Pennington section closed finally on 17 June 1963, two months before the colliery.

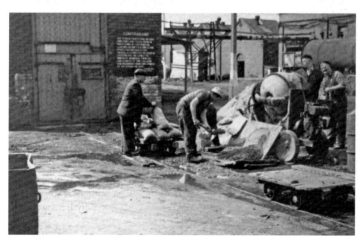

Bagging cement into packing bags of the type used below ground on the face and in stoppings. The airtight doors of No. 2 upcast pit on the left have a small sliding panel to reduce the pressure when opening the doors. Men had no excuse for not being able to read the very large contraband sign warning them not to take matches, pipes or cigarettes below ground!

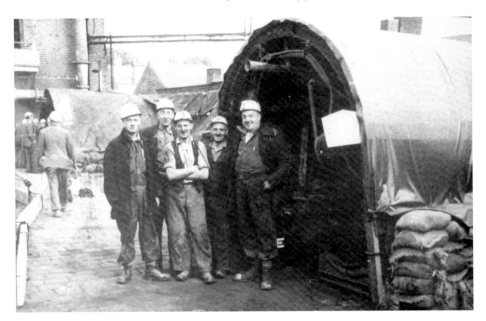

A coalface was 'mocked up' at Gibfield to show men the layout of the new shearer faces in the mid to late 1950s. The shearer, with its rotary disc armed with cutter picks, operated parallel to the face line. Trialled at Ravenhead Colliery, St Helens, in 1952, it was an adaptation of the old jib coalcutters. By 1954, eleven installations were in use in Lancashire, now in use worldwide.

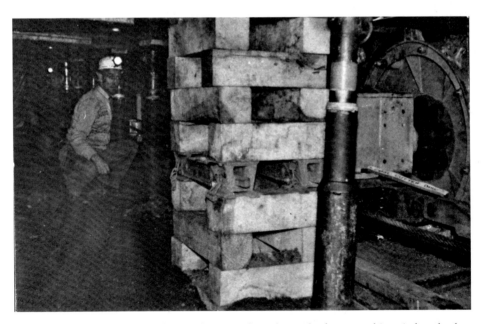

On the mock-up face line, the shearer disc is on the right. In the foreground is a timber chock stack with quick-release metal sections to be released as the face advanced. A Dowty hydraulic face line prop supporting roof channel bars stands alongside.

Washery and coal preparation sheds around the late 1950s. The plant was manufactured by expert Simon Carves in 1944. The concrete washery slurry separation cone would be one of the last features to be demolished at Gibfield.

No. 2 pit at the end of the materials tub lines, timber boards stacked on the left, cable right middle ground and coalface chock stack timbers stacked in the distance on the right.

June 1963 and the last train from Bag Lane to Kenyon Junction is being run as a 'special' for enthusiasts, accommodation made up of no less than five guards vans! Bag Lane station buildings are just visible above the locomotive. The arrival of the railway in 1828-9 brought prosperity to rural Bag Lane. The line's closure, as with many others across Britain, in 1963, took its heart away. Today extensive house and apartment building has once more boosted its population.

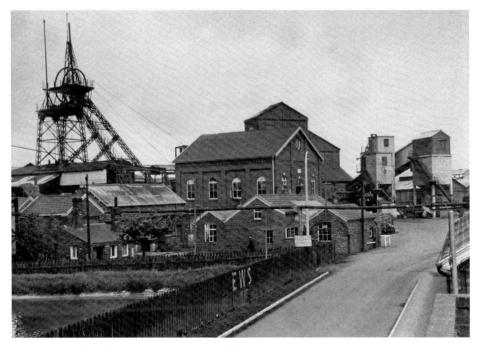

Photograph taken after the announcement of closure in August 1963.

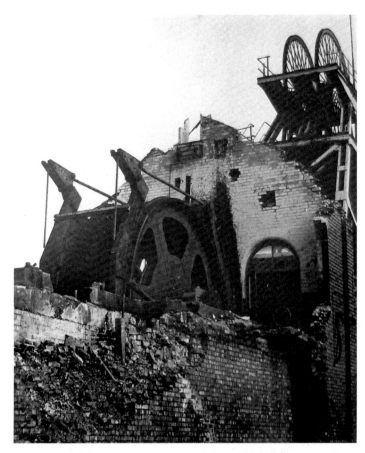

November 1965, No. 2 engine house demolition. The winding engine was built in 1909 by Greenhalgh & Co. of Bolton Road, Atherton, a twin-cylinder horizontal steam, 26 inches x 60 inches. The drum, as can be seen in the photograph, was a parallel type 16 feet 6 inches in diameter and 5 feet 6 inches wide.

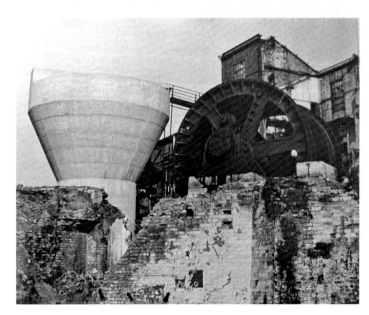

November 1965. The washery cone is still intact, in the foreground is the 1904 13-foot-by-9-foot Fraser & Chalmers winding drum of the Arley Pit.

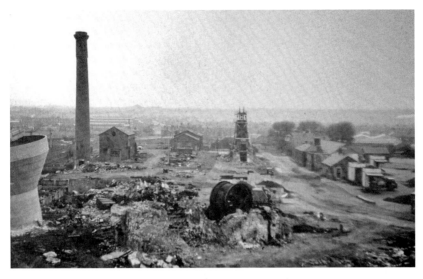

It's May 1966, over two years after closure, and substantial features are still on site. The Old Gib Pit engine house still stands; the washery cone is slumped over, possibly due to a failed demolition attempt. I helped the demolition along with my friends using catapults and nut centres from the nut and bolt works. The Arley Pit shaft was filled with dirt, leaving a methane drainage pipe sticking out of the top. Bits of metal placed in here would rattle down, ignite the gas and be shot back out again. A friend crawled across the narrow girder above the still-open 399-yard-deep No. 2 pit shaft. That nightmare returns occasionally.

As an art student for four years, I based much of my work on coalmining. The visual impact of the industry, lodged in my memory, only resurfaced once I was away from Atherton at college. Here, in 1979, Gibfield is only a coal land sale yard, yet the silhouetted bunkers for bagging coal somehow still inspired me!

Howe Bridge Colliery

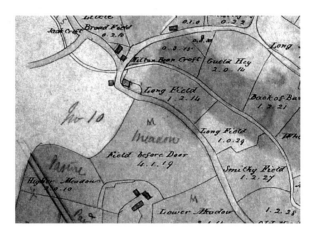

The future site of Howe Bridge Colliery is the field named 'Higher Meadow' (bottom left) on the Lilford estate plan of about 1770. Added later lower left is the proposed line of the Bolton to Leigh Railway of 1828-9. Leigh Road comes in lower right and heads up towards the actual Howe Bridge over the brook (note this was before the road was straightened at the bridge). The brook then passes beneath Lovers Lane (top left).

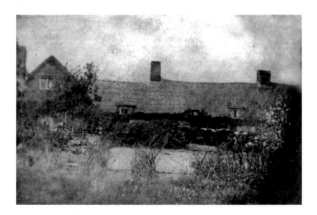

Hatton Fold cottages photographed around 1870. Very small and with thatched roofs, these could date back to the mid-seventeenth century. Atherton's earliest miners around Gibfield probably lived in cottages such as these, the Fletchers buying many properties around the township.

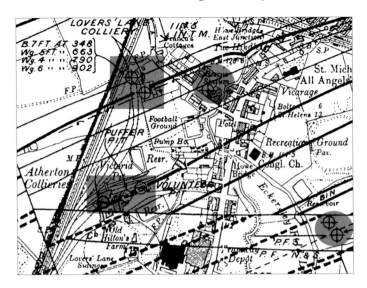

Geological Survey 1929 6-inch 94SE. Thick black lines are coal seams outcropping. To the left is the Lions Bridge geological fault close to the Atherton township boundary. By the late 1840s, geological knowledge from the working of Lovers Lane Colliery (top left) and Oak Pit near Earl Street Howe Bridge (opposite the school) led to the decision to sink two shafts on Higher Meadow field. The winding shaft or Victoria Pit was sunk 149 yards to the Seven Feet, known then as the Great Mine. Note the old shaft to the Seven Feet next door to the rescue station at the bottom of Lovers Lane and the Eckersley Fold ventilation shafts of 1874 for the drift mine to the Crombouke and Brassey seams (lower right).

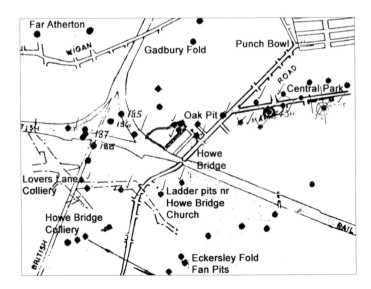

A more accurate idea of the numbers (not exact locations) of shafts close to Howe Bridge. There are probably many more pre-1750 shafts to be found. Please do not take this plan as evidence that a shaft lies under your living room, contact the coal authority, Mansfield, and have a mining search carried out!

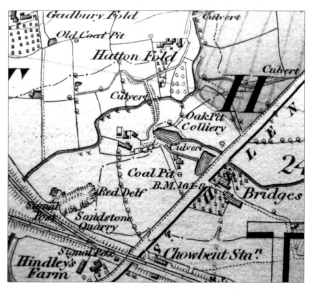

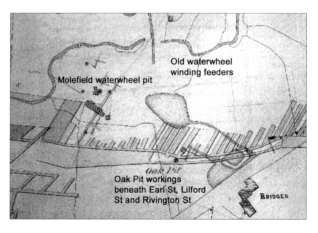

Left: An old, stone-lined ladder pit uncovered by the opencast of 1958-9 close to Howe Bridge church.

Middle: Howe Bridge on the 1849 first-edition OS map. A community of small farms and isolated cottages. The watercourse from the valley near Alder House crosses Leigh Road to feed the waterwheels at the pits. Note Red 'Delf' sandstone quarry; the old term for a quarry was a delf, worked by 'delvers'.

Below left: Opposite Howe Bridge School where Hope Fold Avenue begins once stood Bridges Farm, lower right on this plan of 1840. Oak Pit and Molefield Pit worked the Great Mine (Seven Feet). The plan from about 1770, before the arrival of the pit, shows two fields called 'Moth Holes' close by. These must have been corrupted into 'Moles' then Mole Field. The pits were wound by bi-directional waterwheels fed with water from a watercourse, which began in the valley near Chowbent chapel. Water was reused at the next waterwheel, which pumped water out of the workings, sending it via a 'sough' tunnel into Old Hall Mill Brook. The shallow workings of Oak Pit were the probable cause of severe subsidence leading to the demolition of houses in Rivington Street in 1964. Oak Pit closed in 1849.

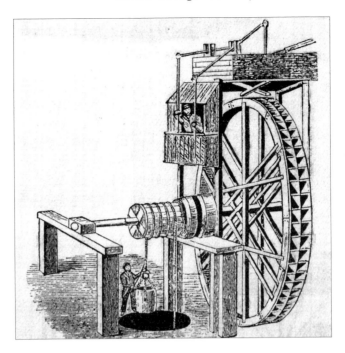

A reversible waterwheel winding arrangement of the type used at Molefield Pit. The wheel at Molefield was probably half set in a chamber, the water hitting it halfway down or 'breastshot'. This meant you could keep the feeder stream at ground level.

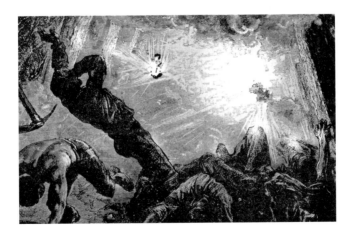

With the arrival of the Mines Inspectorate in 1850, fatal accidents at Atherton's mines began to be documented, mainly single deaths due to roof falls. On Thursday 28 March 1872, a substantial explosion took place at Lovers Lane Colliery a few hundred yards north of Howe Bridge (see earlier plan). Twenty-seven men and boys died due to the use of naked lights in a poorly ventilated area, and this was fifty-six years after the invention of miners' safety lamps! This Victorian engraving gives us an idea of what it may have been like to be in the workings when the ignition took place.

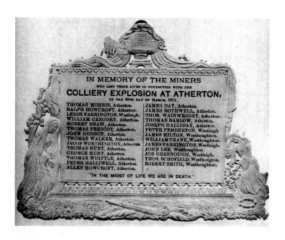

The family of each of the twenty-seven miners dying in the Lovers Lane disaster received a Bible with this accompanying memorial card. Allen Howcroft was sixteen years old and lived at Hatton Fold. Unbeknown to his parents, he had started at the pit and this was his first day. Eighteen men were from Atherton, five from Westhoughton and four from Westleigh. A relief committee was set up including Ralph Fletcher and Abraham Burrows.

The Dead

James Hilton, aged twelve, hooker-on, of New Road, Westhougton.
William Crank, aged twelve, pony driver, of New Lins, Westhougton.
James Rothwell, aged sixteen, drawer, of Market Street, Atherton.
Thomas Walker, twenty, dataller, of High Street, Atherton.
James Farrington, aged twelve, pony driver, of Malley's Row, Westleigh.
Leigh Farrington, aged thirty-five, head fireman, of Malley's Row, Westleigh (wife and four children, and father of James).
Thomas Hunt, twenty-one, waggoner, of Bag Lane, Atherton.
Joseph Holliday, fourteen, rolly hooker, of Bridges, Atherton.
Ralph Holcroft, thirty-five, deputy underlooker, of Bridges, Atherton (wife and three children).
Job Greenhough, twenty-six, collier, of Tickles Row, Westleigh (wife and three children).
John Lee, thirty-four, collier, of Daisy Hill (wife and six children).
Allen Howcroft, sixteen, waggoner, of Hatton Fold, Atherton.
Thomas Schofield, nineteen, dataller, of The Ashes, Atherton.
Peter Halliwell, dataller, of Bag Lane, Atherton (wife and one child).
Robert Shaw, thirty-two, dataller, of Water Street, Atherton (wife and four children).
John Hodson, thirty-eight, collier, of Bag Lane, Atherton (wife and five children).
Thomas Morris, seventeen, surveyor's apprentice, of Market Street, Atherton.
Thomas Whittle, nineteen, drawer, of Guest Fold, Atherton.
James Day, thirty-two, collier, of Dan Lane, Atherton (wife and three children).
Thomas Prescott, thirty-seven, drawer, of Bag Lane, Atherton.
Robert Smith, twenty-four, collier, of New Rock, Westhougton (wife and one child).
George Hunt, fifteen, pony driver, of Bag Lane, Atherton.
Peter Pemberton, twenty-eight, dataller, of Malley's Row, Westleigh (wife and four children).
Thomas Wainwright, twenty, collier, of Bridges, Atherton (wife and one child).
Thomas Barlow, seventeen, drawer, of Lane Top, Atherton.
Jacob Worthington, eighteen, collier, of Bridges, Atherton.

William Grundy, of High Street, Atherton, died two days after the explosion due to burns.

Right: The 'bicycle' pit headgear at Howe Bridge. The first winding-engine house was at right angles to the later one with a normal two-pulley layout. This explains the wheels having to go one above the other as the cage and guide rope arrangement remained the same. Dating back to 1879, pit headgears were usually made of Dantzig timber or pitch pine. This example survived until the colliery closed in 1959.

Below left: Widespread unrest across the Lancashire coalfield in 1881 led to meetings at Leigh. On Friday 28 January, the men heard that miners at Howe Bridge had gone below ground so headed off there. The Riot Act was read (top left) and the Hussars duly arrived to charge the men off site wielding their swords. A full and often humorous account of the events was published in the *Leigh Chronicle*.

Below right: To mark the battle, Atherton brass founder Mr R. Greenhalgh struck a medal that was presented to the officer in charge of the Hussars. A second medal, cast in lead, was made at Gibfield Colliery. For many years, a brass medal was hung, framed in a mount in Atherton Library along with a copy of the account; sadly, no longer. I have not been able to trace its present whereabouts.

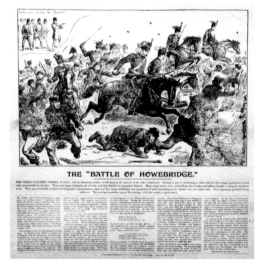

THE "BATTLE OF HOWEBRIDGE."

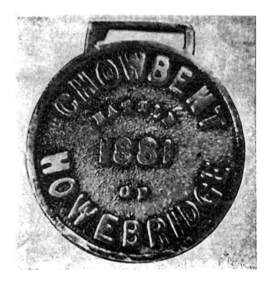

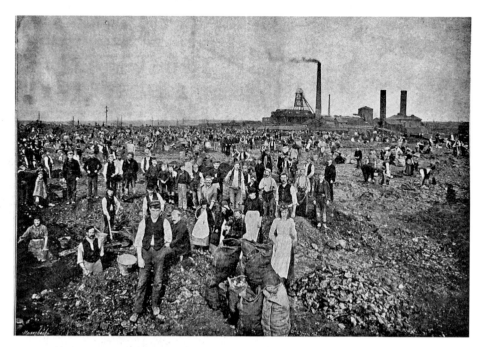

1893 strike supplement to the *Leigh Chronicle* published in 1894. A magnificent photograph of Howe Bridge Colliery from the south-west. Howe Bridgers, and probably mining families from the other Atherton sites, are coal picking on the waste heaps. The small chimney in the distance is at Lovers Lane Colliery.

Inefficient hand picking and screening at the pit led to large amounts of useable dirty coal ending up on the tips. The company had given permission in late September 1893 for the families to pick for coal to alleviate severe hardship. The strike had been called over the 'sliding scale' where wages rose or fell with the price of coal, and recently the price of coal had collapsed. The men had walked out on Sunday 29 July and returned on 17 November to accept a smaller pay cut than had been planned. It was to be 1912 before a minimum wage was in place.

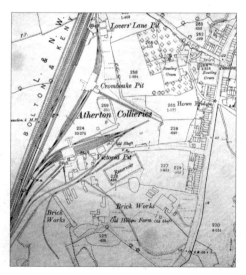

Left The 1894 25-inch OS map gives us a fascinating glimpse into the arrangements on site. Two brickworks are operating near Old Hilton's farm. An old shaft is nearby, possibly of the early 1800s, working seams beyond the 36-foot fault, which passes through the site north-west to south-east. The Day Eye to the Crombouke seam is still in use (closed 31 December 1907), its long staging entering the ground near Oak Street. Higher up is Lovers Lane Colliery (closed August 1898).

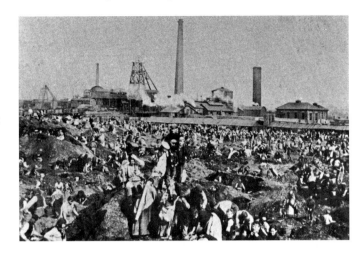

1893 strike coal pickers. On the right is the Volunteer Pit chimney above a formerly furnace-ventilated shaft sunk in 1861. To the left is a rare glimpse of Lovers Lane Colliery, its open-structure tapering pit headgear supporting a single pulley wheel. Sunk around 1815, it closed in 1898 and is only ever seen in the 1893 strike photographs.

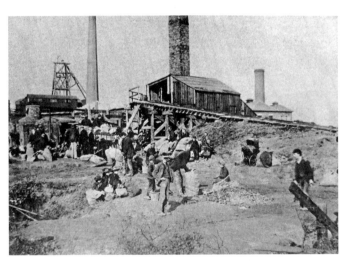

1893 strike. View near the westerly of the two small brickworks on site, the inclined tram road supplying it with clay on the right. The square kiln chimney stands behind the tippler shed; a smaller squat single kiln can be seen far left.

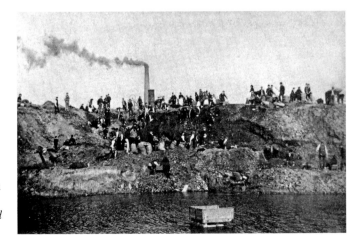

1893 strike. Rich pickings at the side of the old, water-filled clay hole for the brickworks. A number of soup kitchens were set up around Atherton to alleviate the hardship of the strike. Lord Lilford donated £50 to the relief funds. Over thirteen weeks 114,692 meals were served at a cost of about 1¼*d* per meal.

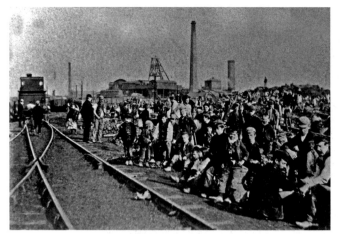

1893 strike. At the side of the LNWR line (the old Bolton to Kenyon) with Lovers Lane Colliery chimney in the distance. The men had arranged for carts to collect their bags of coal. The man in a dark jacket and distinctive cap talking to a miner is similar to J. S. Burrows as seen in a sketch for the booklet 'An Order For The Pit' of around 1886.

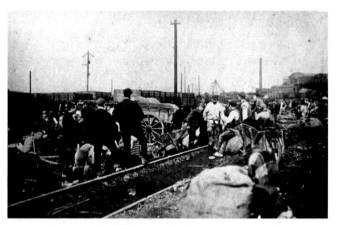

1893 strike and Lovers Lane pit headgear in the distance. Carts and wheelbarrows are in use to take the coal away. Note the old semaphore-type signal on the railway behind. It is interesting, as regards the quality-conscious coal market, that the company allowed men to take away perfectly useable coal that was so dirty they would never have tried to sell it.

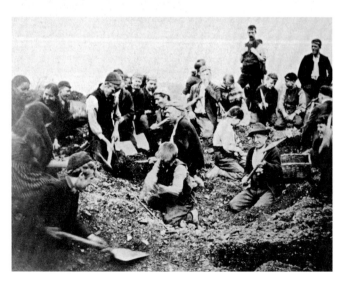

1893 strike. All the family are involved in the search for scraps of coal or coal attached to dirt bands. The chimneys of Howe Bridge and Atherton must have been quite a sight when this lot was being burned, the odd bit of iron pyrites adding to the sulphurous smell!

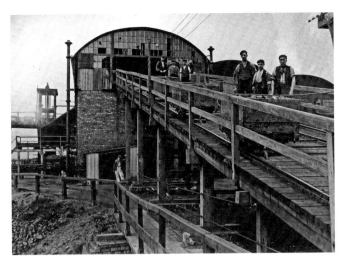

1905 series. The staging for tubs being drawn out of the Crombouke Day Eye mine (a 'walk-in' drift mine) probably by an endless wire rope. Catches on the floor stop tubs rolling back down in case detached from the rope. A man reminiscing about when this was working (up to 1907) said you could hear the rumble of the tubs below when having a pint in the Oak Tree Root pub.

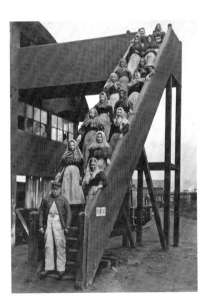

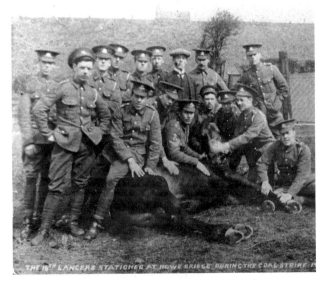

Above left: Pit-brow women with the surface foreman. He was in charge of coal quality and the efficient dispatch of customer orders, which could be from far afield. Buyers became very partial to certain coals, the Crombouke at Howe Bridge being 82 per cent carbon with less than 2 per cent ash (the photograph of the Day Eye gantry has a Ramsbottom Co-op wagon in the background).

Above right: The 16th Lancers from Wigan stationed at Howe Bridge during the 1912 strike probably around 7 April. The dispute, which had started at the beginning of March, was over claims for a minimum wage, and although the men went back to work with what was nationally considered a victory, militants continued to cause trouble, even minor riots around Leigh and Atherton.

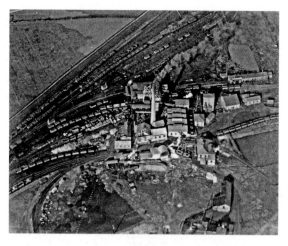

Howe Bridge from the air in 1925. The small pit headgear to the right of the main one was above the 145-yard nine-feet-diameter 'Puffer Pit' pumping shaft. From 1862 until 1925, the pumping was carried out by an old beam engine named 'Colonel'. Lovers Lane Colliery had been sited just off the top of the photograph. The Day Eye gantry had been beyond the reservoir top right.

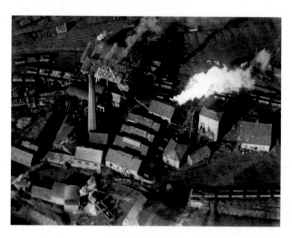

Detail of the aerial photograph of 1925. The small 'Puffer Pit' headgear was wound by a horizontal twin-cylinder engine, 10 inches in diameter by 18 inches stroke, its drum was 5 feet diameter by 2 feet wide. A single-deck cage was wound. The four buildings in line in the centre are the boiler houses. Left of the chimney is the earlier engine house. From 1922, the Six Feet coal had been wound.

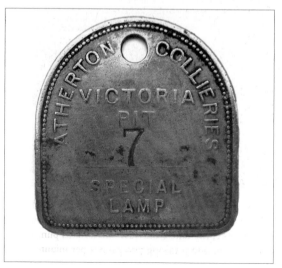

Rare Howe Bridge Colliery, Victoria Pit lamp-room tally. Marked 'Special Lamp' this was for the recently introduced electric cap lamps. This was initially reserved for men who really needed 'hands free' lighting, tunnellers or shaftsmen, for example.

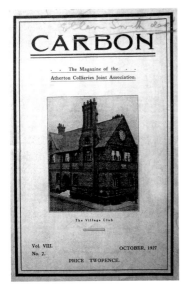

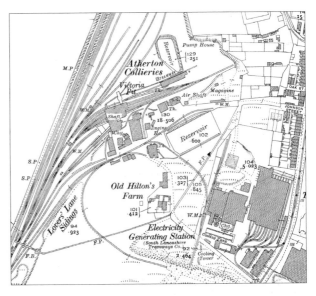

Above left: Carbon, the magazine of Atherton Collieries Joint Association, Vol. 8, No. 2, October 1927 with Howe Bridge village club on the cover. The vast amount of material of social interest within *Carbon* gives us a very full picture of life in Atherton from 1919 to 1929 when Manchester Collieries was formed.

Above right: The 1926 25-inch OS map of the area now includes the South Lancashire Tramways Co. electricity-generating shed, a line feeding it directly from the pit.

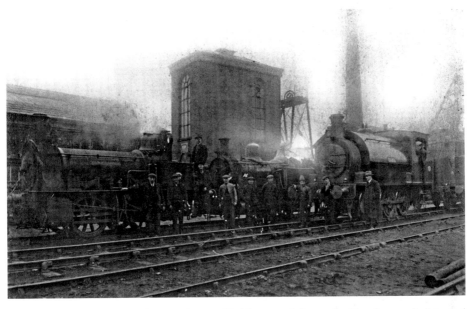

0-4-0 *Ellesmere* (later *1861*) by Hawthorns of Leith, 0-4-0 *Atherton* by Hawthorns of 1867, and 0-6-0 *Colonel* by Hunslet of Leeds feature in this specially arranged shot. The tall engine house was built for the original John Bull beam pump of 1851, the date stone just visible. This pump was replaced by the 1862 'Colonel', a Cornish-type beam pump raising 700 gallons per minute.

 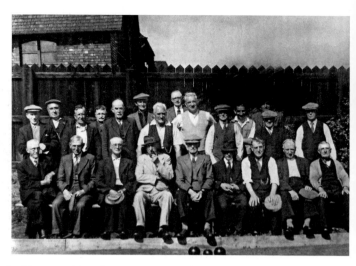

Above left: The former ticket office for Howe Bridge railway station seen from 'The Prom'. Here, in the early 1930s, it is a general shop, today a residence. I remember the frightening enamel signs for 'Five Boys Chocolate' and the now ironic message of 'Craven 'A' Will Not Affect Your Throat' in the early 1960s.

Above right: Atherton Collieries bowling team at Howe Bridge around the late 1930s. A comment in *Carbon* magazine in 1929 stated they had been 'very unsuccessful' although midway up the local league. It was hoped that younger members would be attracted, and looking at the photograph, I can see why. Some decent-sized flat caps are in view.

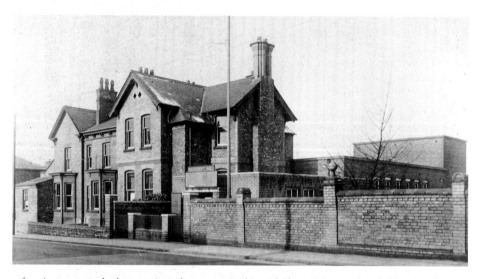

Briarcroft as it was named when a private house received its title from Brierycroft, a field name close by on the estate plan of about 1770. Dating back to the mid-1870s when the development of Howe Bridge was taking place, it was originally the home of Colonel Philip Fletcher (1846-1927). He gave it to Atherton Collieries Joint Association in 1921 retiring to Woking. An extension hall part funded by the Miners' Welfare Fund was added in 1935 (visible on the right-hand side). This was the first grant assigned for leisure use in the Lancashire coalfield. Designed by Taylor & Young of Manchester, it was insensitively given permission for demolition by Wigan Council in 1997 to make room for flats.

Right: Miners walking home towards Smallbrook around the 1940s. Behind is the Lancashire United Tramways generating building and wooden water-cooling tower. Wearing flat caps, clogs, scarves and carrying their 'snap' food tins and water cans they are unmistakably miners. In 1943, Jim Fletcher managed the pit when 284 men worked below ground and 126 on the surface.

Middle: Jim Fletcher was born in 1912, the son of Clement Fletcher. Living at Culcheth today, he is as lively as ever and has vivid memories of life in Atherton over the years. Jim gained his colliery manager's certificate, managing Howe Bridge Colliery from 1939 to 1943, later moving on to safety engineering in the industry. Jim remembers trade union relations being good at Atherton Collieries and that his father was so fond of Atherton, he only missed two Christmases through the war. Jim is the last of the line of mining Fletchers, a dynasty stretching back over 300 years. Here he indicates to me the layout of the surface buildings at Howe Bridge pit.

Below right: Brassey coalface, December 1939. The chain coal cutter is heading along the face line. The seam has been undercut and spragged with metal wedges, its middle dirt has been taken out and wooden 'nogs' hammered in. The cutter has a 'gummer' attachment to clear the dirt away from the face. The roof supports are metal-wedge friction props with channel bars above.

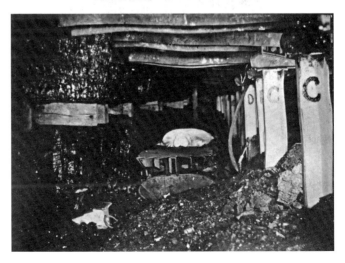

Brassey coalface, December 1939. The cutter has passed, the dirt has been cleared up and thrown in the waste to the right. All the wedges and nogs are in place. 'Sprag props' have been set against the top coal, many men dying over the years due to top coal coming onto them. The Brassey consisted of 1 foot 7 inches of top coal, 4 inches of dirt, then 2 feet 6 inches of bottom coal.

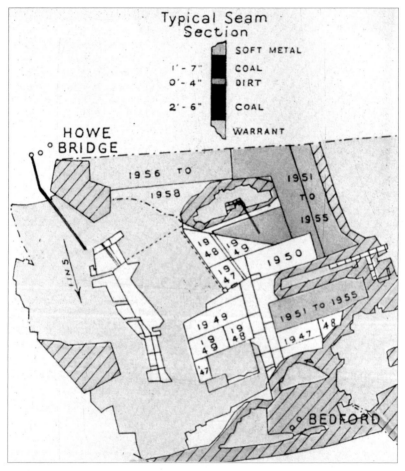

Manchester Collieries Technical Report in about 1946. Planned workings in the Brassey seam, 1947 to 1958. The pillar (below the words Howe Bridge) beneath the LUT was to remain unworked. Although classed by the NCB as exhausted, on closure, hundreds of millions of tons were yet to be worked in the Bin seam and also in barriers between collieries.

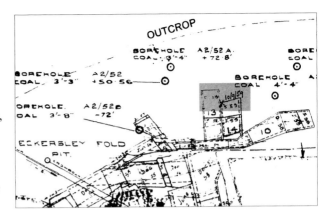

The final days of Howe Bridge as rise coalfaces in the Brassey head up towards the outcrop across Bee Fold Lane. The last cut on 14's face, shaded area, is dated 10 September 1959, one day before the official abandonment of working date. An old farmer told me you could hear the rumble of shots being fired they were so close to the surface!

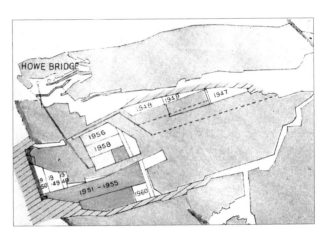

Manchester Collieries Technical Report, *c.* 1946. Proposed Rams seam workings from 1947 to 1960. A top-quality coal locally known as the Six Feet, this was obviously near exhaustion by the time of nationalisation in 1947 when 322 men worked below ground and 143 on the surface.

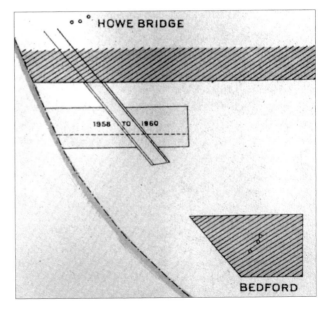

Proposed Bin seam workings, *c.*1946. To be approached by two drift tunnels, it was estimated that 4.6 million tons of this 4-foot-6-inch seam were present. The seam outcropped partway down Eckersley Fold Lane and close to the LUT generating sheds. It was not to be worked, being partly opencasted at a later date.

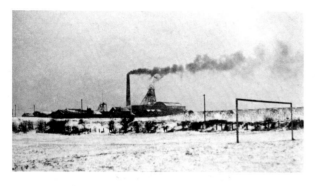

A superbly atmospheric winter shot from the football field off Lovers Lane around the early 1950s.

Henry Talbot (1885-1958) was the undermanager at Howe Bridge on nationalisation in January 1947. Here, he is in his very small office at the pit. He delegated for the colliery manager below ground and had to be a real 'hands-on' type having a thorough knowledge and experience of mining techniques, the legalities of the task, as well as geological and planning skills.

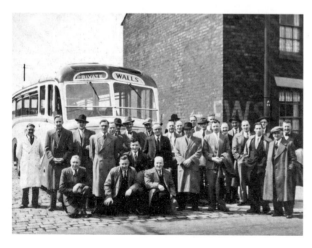

Howe Bridge shotfirers off on an outing around 1954. These men would be on the move all through the shift, firing shots in tunnels, on the face and face-end rips, also making manholes in haulage roads. They would also be the butt of the men's humour wherever they went!

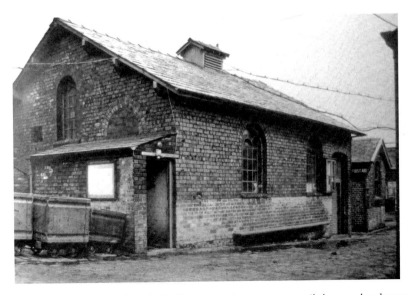

Photo of the late 1950s. The original winding-engine house in use until the new headgear was erected in 1879. At right angles to the later one, this explains why the pulley wheels at Howe Bridge were set one above the other, as the cages were in line with it. This became the trial miners' baths of 1913, the first in Britain. Note the old winding rope square hole in the wall on the left and the bench for the men waiting to go down the pit.

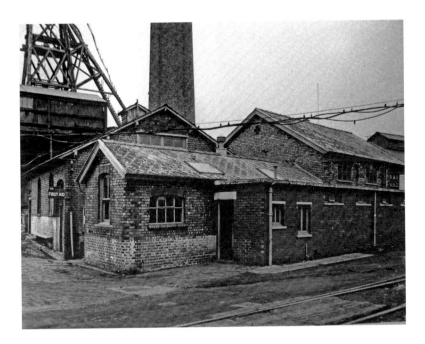

1950s photograph. From the left, first-aid post, the first winding-engine house of around 1850, manager's office and baths. The orientation of the early engine house to the side of the headgear can be seen.

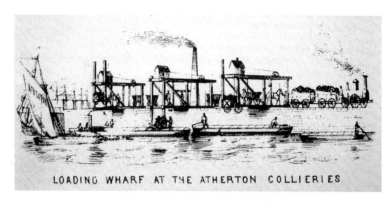

LOADING WHARF AT THE ATHERTON COLLIERIES

An Atherton Collieries sales booklet *Black Diamond Almanac and Tide Table* was published in 1859 and was intended to be distributed to customers at the Atherton Collieries Liverpool sales office hence the tide table aspect. With the booklet came a description of the company's products and canal wharf arrangements at Bedford Basin, Leigh, on the Bridgewater Canal. This illustration shows coal wagons (it is said that the actual tubs from the pit were used) being lowered and emptied into barges. Great reduction in coal breakage was claimed for the arrangements in use. The locomotive shown is either an artist's impression or an actual locomotive that travelled the line through the tunnel near the former Leigh Station. No record has surfaced as yet which describes a locomotive preceding *1861*, but one may have existed for a short period after the horse tramway went into disuse. Note the barge on the left with the sail titled 'Atherton'.

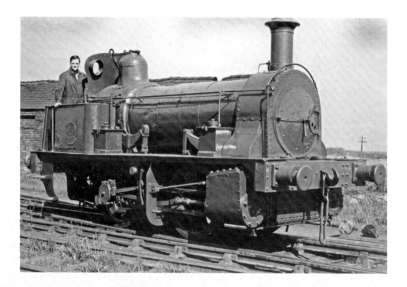

A good record photograph of loco *1861* by Hawthorns of Leith, now preserved in the National Museum of Scotland, Edinburgh. Taken possibly during the last year of Howe Bridge's life in 1959. This locomotive, with its cut-off cab, used to travel the tunnel close to Leigh station to Bedford canal basin. It once (date not with the record) turned over completely due to its buffers locking with the first wagon as it emerged out of the tunnel on the Leigh side. The driver and brakesman survived, three others were injured.

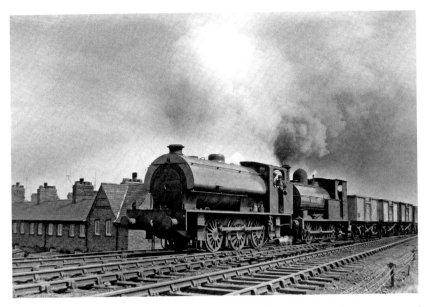

Loco *Gordon*, 0-6-0 by Robert Stephenson & Hawthorns of 1945, ex-war department, purchased by Manchester Collieries, and loco *Crawford* at Howe Bridge. *Gordon* was working at Chanters by April 1946; then at Gin Pit, Tyldesley, from 1950 to 1951; back to Chanters in mid-1959; and later Bickershaw Colliery, 1960-1961. It was scrapped at Bickershaw in October 1966.

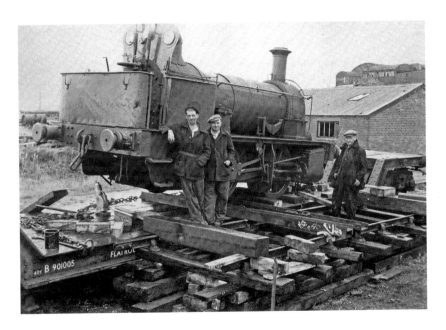

Loco *1861* was originally named *Ellesmere* and was purchased brand new by John Fletcher & Others. Its title was changed after Manchester Collieries formation in 1929 to simply *1861*. No crane in sight to load it on the 40-ton-capacity low-loader wagon, just manual timbering and raising. It is heading initially to the Scottish Railway Preservation Trust's yard at Falkirk.

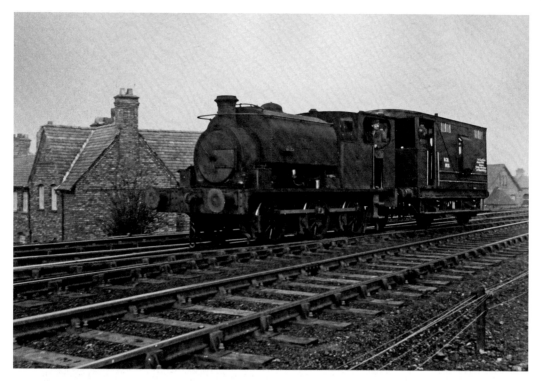

Mid-1950s and loco *Edith* has just passed over Howe Bridge station bridge heading towards Gibfield. *Edith* had been transferred from Tyldesley Coal Company's Shakerley Colliery in late 1938, early 1939. By 1947, the NCB were using it at Gibfield Colliery. It was withdrawn in December 1956 and scrapped by May 1959.

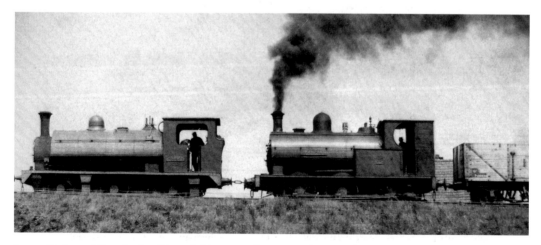

Locos *Violet* and *Crawford* at Howe Bridge around 1960. *Violet* came from Gin Pit Tyldesley (Astley & Tyldesley Coal & Salt Co. Ltd) to Chanters in 1943-4. Sent to Walkden Yard for repairs mid-1962, scrapped by October 1965. Loco *Crawford* (after the Earl of Crawford & Balcarres, Haigh Hall) came to Gibfield from Wigan Coal & Iron Co. Ltd in March 1957. It was scrapped at Gibfield in May 1964 after closure.

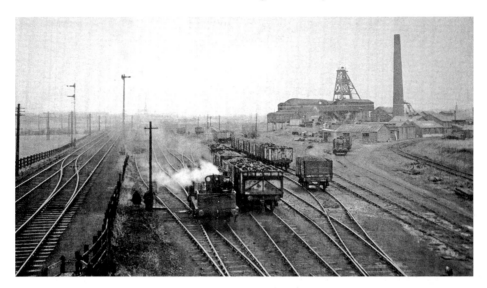

A fascinating view of Howe Bridge from the south-west on a gloomy day in late 1956. Loco *1861* is at work in the sidings where, in the 1893 strike, the coal pickers awaited their coal carts. Howe Bridge has the look of a very old colliery with its elevated ramshackle sheds and screen structure, and its splayed-leg pit headgear similar to Lovers Lane Colliery.

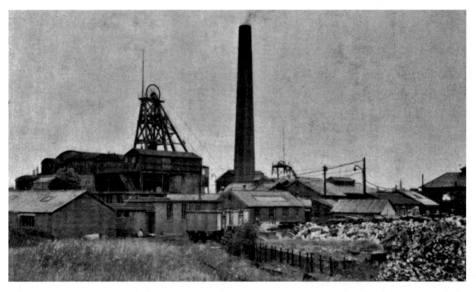

Photograph taken on closure of the colliery in September 1959. In later days, Howe Bridge had operated a miners' training centre and was even converted to skip winding to boost shaft capacity as late as 1955. This was, apart from reducing manpower by thirty-two, not hugely successful, with an increase of only 23 per cent, or 30 tons per hour. In 1956, the Clean Air Act dealt a body blow to the use of coal. Although the National Coal Board classed the closure as 'due to exhaustion of reserves', the fact that the Bin seam reserves of 4.6 million tons were left in the ground says a great deal for the energy situation in Britain looming on the horizon with competing fuels, oil, gas and electricity. The greatest period of British colliery closures in history lay ahead.

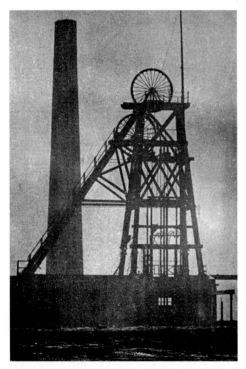

Left: The dramatic outline of the old 1879 wooden pit headgear at Howe Bridge after most of the site had been demolished. Its basic design and dimensions were probably similar to Lovers Lane Colliery close by, although that seems to have been a single-pulley arrangement.

Below: View of 'The Prom', Howe Bridge, taken in 1982 from the bridge, which had been temporarily reinstated with a Bailey bridge-type structure during the opencast operations to the west of Millers Lane. Built from around 1873 onwards to the design of Medland Taylor, this was probably the finest workers' housing in the country in its day. It is now a conservation area with a hopefully secure future.

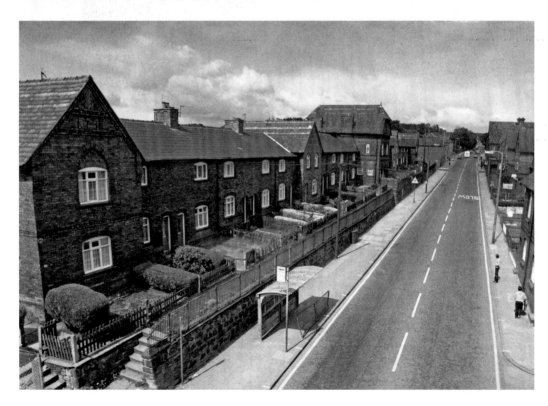

Chanters Colliery

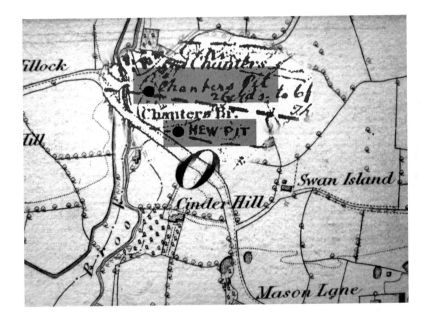

The Act to Provide for the Inspection of Coal Mines was passed in 1850. The first inspector to cover the Atherton and wider Lancashire area was Joseph Dickinson (1818-1912). He realised the dangers of undocumented old workings and, in his travels, tried to glean local knowledge to build up a picture of their extent. In his very hard-to-read overlay, above, of the first-edition plan of 1849, he has sketched in the site of two shafts down what is now Tyldesley Old Road, Chanters Pit, 26 yards deep, and New Pit. Being opposite Chanters itself, this is a good candidate for Chanters Gold Pit, New Pit being around 1850. In a survey book of 1816, there is an extract:

> Chanters Gold Pit. This pit was an old engine pit supposed not to have been worked during the same century. In it were found several gold coins of King Charles I (1625-1649) with the plates from which they had been punched.

With the Rams seam outcropping in the Valley behind Chanters and the Brassey seam outcropping in the brook very close to this shaft there is every chance this could indeed be a seventeenth-century shaft. The adjacent Chanters building is dated 1678, although it is thought to be older. The coins of Charles' period build up a strong and intriguing case.

The shaft shown as New Pit appeared again in about 1982 under a house in Tyldesley Old Road, apparently 180 feet deep!

The future site of the modern Chanters Colliery is the field marked Near Bank (top centre) on the Lilford estate plan of about 1770. The future Tyldesley Old Road is the one heading off to the left; Lodge Lane is at the bottom; 'Hindford' bridge is to the right.

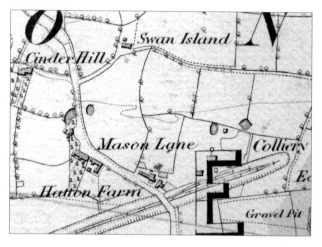

The 1864 revision of the first-edition plan of 1849. Chanters siding is now in place, recently built at the expense of the London North Western Railway. The only shafts (the two small circles near the top of the large letter E) appear to be near the site of the future No. 1 pit. Nothing is shown at the site of No. 2 pit where sinking may have been in progress.

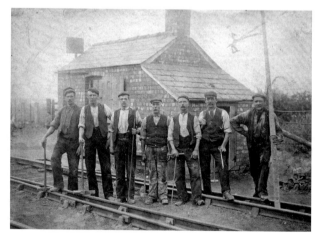

Fletcher Burrows track-maintenance men on the LNWR Chanters branch near their hut down Millers Lane, c. 1910. William Ashmore, fourth from left, later became involved in house building; he built the terraced cottages in Ashmore Street off Sale Lane, Tyldesley. They were named after him.

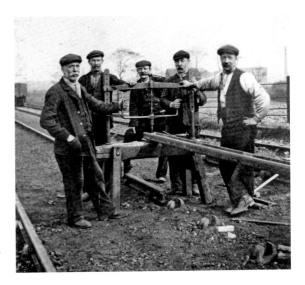

Around 1910. Trackmen drilling rails for fishplates on the Chanters branch line.

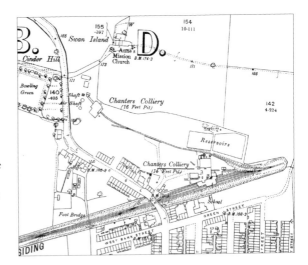

The 1896 OS 25-inch map shows two shafts at the site of Chanters No. 2. One may have been the fan drift linked to a surface ventilation furnace rather than a deep shaft, replaced with a fan in 1896. The main entrance to the pit at this time appears to be next to the bridge at Hindsford over the sidings line.

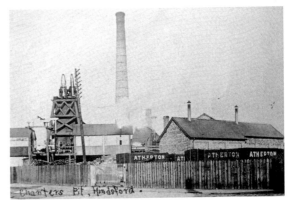

Good, clear postcard view of Chanters No. 2 pit, c. 1904, taken from Tyldesley Road. The old, wooden pit headgear survived until 1926. This was the upcast ventilation shaft. The furnace which had ventilated it by drawing air up the shaft was replaced with a fan in 1896.

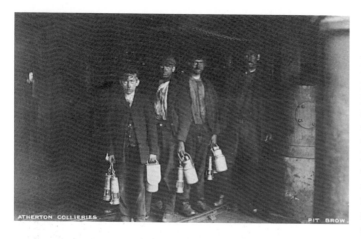

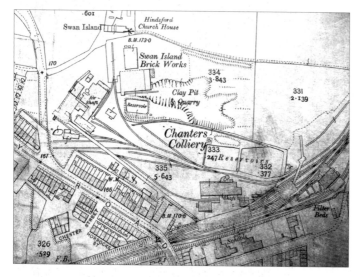

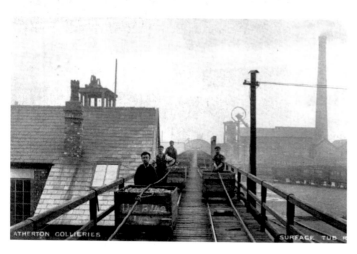

Left: Boys emerging below the surface gantry at Chanters No. 1 pit. From the 1905 series of photographs, this being a postcard version. The cage at the time had three decks, each of which took two tubs of 10 cwt capacity. No. 1 pit was steam wound until 1956, ten years before closure, when electrification took place. These lads were at the mercy of the older miners, some of whom were on piecework. They either toughened up with the years or left the pit.

Middle: 1905 revision specially enlarged OS map showing Tyldesley Old Road heading off top left, Tyldesley Road at the bottom. It's the early days of Swan Island brickworks with just one small clay hole. On the left is No. 2 pit linked via the tub gantry to No. 1 pit. Miners' housing right next-door to the pit meant that there was no excuse for being late. It was just a two minute walk; handy if you were on days.

Below left: 1905 series postcard. On the tub gantry between No. 2 pit washery and screens and No. 1 pit screens. The tubs are lashed by chain onto an endless-rope haulage system. One boy per tub may mean that they occasionally came loose when snatching of the rope took place. The boy to the right is stood in the empty tub hanging onto the rope having a free ride back to No. 2 pit!

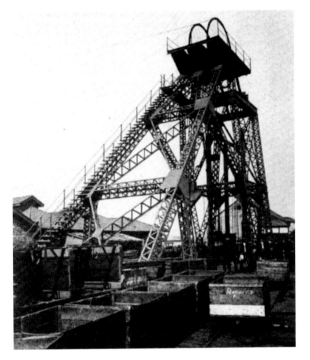

1905 series postcard of No. 1 pit lattice steel headgear, erected in 1904. No. 1 shaft was 14 feet in diameter and intersected twelve workable seams, the Arley being reached at 610 yards. An old beam pumping engine from around 1780 transferred from Howe Bridge Colliery and named John Bull was in use here until the early 1930s.

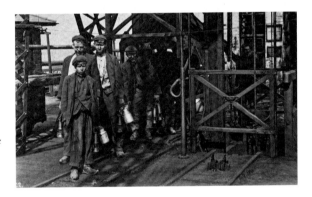

1905 series. A superb photo of miners emerging from the cage at No. 1 pit. Note the boys' work clothes, hand-me-downs from his dad or brothers no doubt. These men and boys would have to walk home 'in the black' before getting a wash in the tin bath. The water cans were needed in the very hot Arley workings.

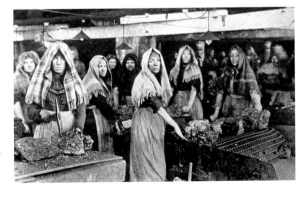

1905 series. Screen women pose for the photographer; the coal-dressing lady on the left is none too keen. Most of these women would have husbands working down Chanters. Fletcher Burrows provided good-quality housing alongside the colliery, with husband and wife back home together by about four o'clock.

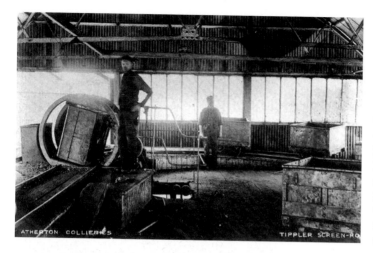

1905 series postcard. The screen room 'kick' tub tipplers at Chanters. Normally each tub would have its axles greased on being turned over. Facilities at Chanters were state of the art and regularly visited by other envious colliery officials.

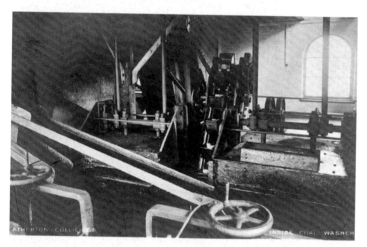

1905 series postcard. The coal washery at Chanters was built 'in house' in 1901. Two Coppée felspar 'jig' boxes with either a dirt or coal elevator in the centre are visible. Dirt is heavier than coal so if oscillating motion is given to the mix along with water, separation occurs. This was not an exact science so picking on the waste tips could still be worthwhile, although not normally allowed.

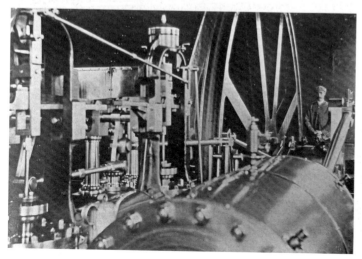

No. 2 pit winding engine of 1896, its winding drum 19 feet 9 inches in diameter by 8 feet 3 inches wide. Photographed around 1900.

Right: Winding-engine man Tom Gerrard alongside the cylinder of the Greenhalgh & Co. of Atherton steam winder for No. 2 pit. It was built in 1896 with cylinders 28 inches by 60 inches. Unusual in having 'side by side' Cornish valves this was still in place on closure in 1966.

Below: Chanters No. 2 pit winding engine photographed around 1900 showing cylinder, valve gear and signals board in the background. A closer look shows signals for the mouthings at the Seven Feet, Five Quarters and Yard insets.

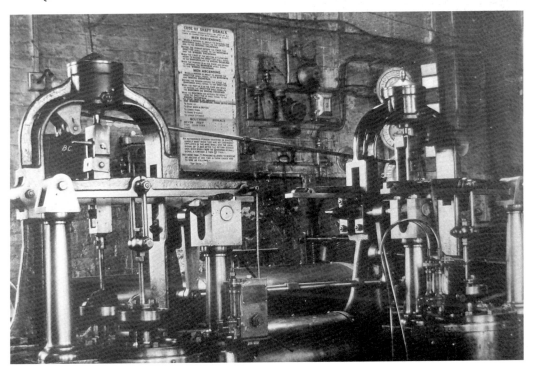

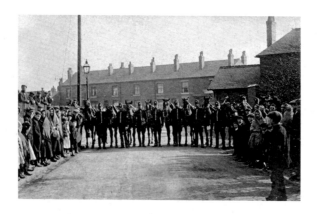

The 1912 strike with mounted police in attendance. The view taken on 11 April is from Tyldesley Old Road looking towards Tyldesley Road (if you stand there today the row of houses is virtually identical in appearance). Although the men had returned to work with a minimum wage, militants were determined to stay out for further improvements in working conditions.

J. S. Burrows writing to the *Manchester Guardian* stressed the threatening atmosphere prevalent at Chanters:

> On Saturday, 6th April, following the decision of the Miners Conference in London, the Secretary of our local union wrote to me that the Conference has decided to resume work. Accordingly the datallers (general workers paid by the day, men on a 'day tally') were sent down at 10 p.m. on Sunday evening as usual, to prepare for coal winding the following day. Whilst the men were going down they were annoyed by strangers from other districts who resented anyone going to work till they felt inclined to do so. Later on, a rush was made to the pit brow, an attempt made to lift the doors, to push tubs down the shaft, 600 yards deep, and so to damage the shaft and winding apparatus and prevent any coal winding for some time. But this would have imprisoned the men then in the mine, and sooner than run any risk of this, and under threats to cut the winding ropes, we had to make terms with the gentle mob of 800 persons, and agreed to bring the men out of the shaft.

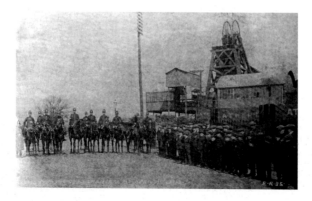

The same event, this time looking towards the colliery and No. 2 pit. Local photographer 'E.R.' certainly spotted an opportunity; this postcard is numbered 35, and frustratingly, I have only ever seen six so far. I have an old postcard of North Road numbered 150! Hopefully, more of the series will surface over the years.

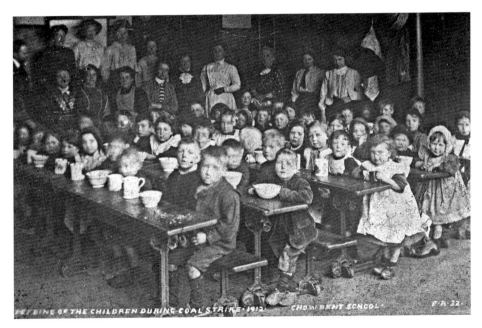

The 1912 strike and number 32 in E.R.'s series of photographic postcards, this is of miners' children being fed at Chowbent School next to the Unitarian chapel. Soup kitchens and 'feeding stations' were set up in various parts of Atherton, the wives of the Fletchers and Burrows even helping out. Look at the range of sizes of containers brought.

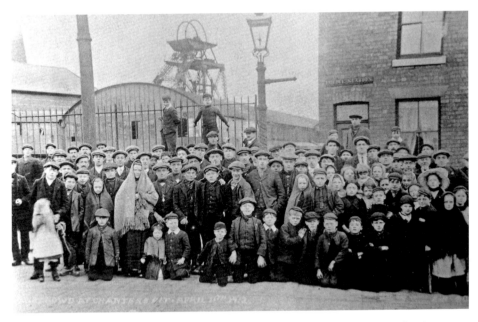

Photographer E.R., again on 11 April 1912, this time showing a group of mining families near to the railway bridge at Chanters sidings Hindsford. The terraced house behind is the police station, which might be the reason the group are meeting there.

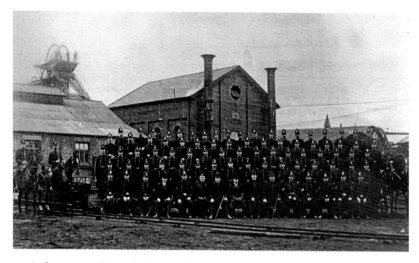

The event is the 1921 strike and, after the lessons learned during the 1912 strike, we have no fewer than eighty-three policemen on duty near Chanters No. 1 pit. Three lookouts stand on top of the pit headgear. The strike over wage reductions after the First World War and the end of wartime nationalisation began on 1 April and lasted for eighty-nine days. This time the violence of 1912 was not present and good feelings prevailed, with Fletcher Burrows helping their workforce's families as best they could. The miners could not be said to have won but had reduced the pay cuts that had been planned with the aid of a government subsidy.

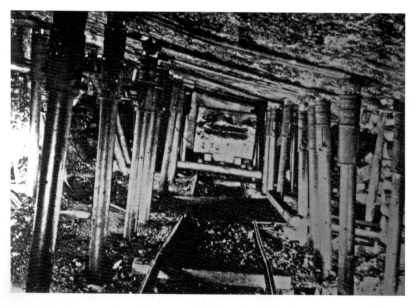

A tub waiting near to the Yard mine rise coalface (on the left). A sprag prop keeps it in place, behind it is a sheet of brattice cloth, used to course air round districts. A metal plate allows the tub to be turned round and lowered down to the haulage level. The metal supports are early 'friction props' designed to accept a certain amount of roof convergence before being damaged. Above them are metal corrugated 'straps'.

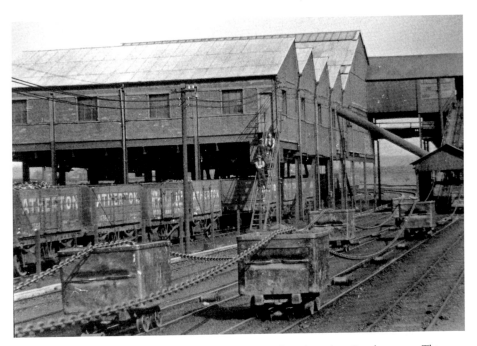

Endless-chain haulage taking tubs to the new screens and washery, late October 1927. These were sited near the 'Piggy Bridge' eastern end of the colliery site. Given the title the 48s screens after the Four Feet (Victoria) coal, which had that brand name. The washery was built by the well-known Coppée company.

Aerial postcard view by the Imperial Aerial Company of Manchester in early 1926. In the shot of Chanters sidings on the left are the 48s screen sheds east of No. 1 pit, before the erection of the adjacent washery.

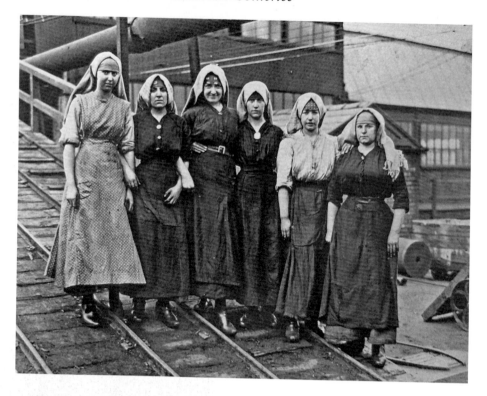

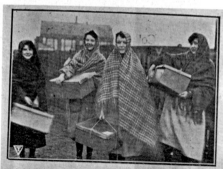

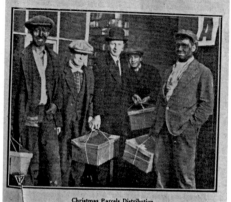

Christmas Parcels Distribution.

Above: Pit-brow women at Chanters around the early to mid-1920s. Note the single-buckle, brightly polished clogs. This was a tough job in the middle of winter but their camaraderie made it bearable. Young lads starting at the pit on the surface were often subjected to an 'induction' by the women, of a type best not to mention here.

Left: 1920s. Due to the generous distribution of Christmas parcels to the workforce at Chanters Colliery, it was nicknamed 'Turkey Pit', even long after nationalisation in 1947. The choice was a huge turkey or a food hamper by Rushtons of Wigan.

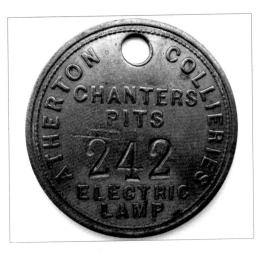

The survival of these 1920s Atherton tallies (perhaps made by A&BM) is so rare they will be featured individually. They may be unique survivors and only appeared at auction a couple of years ago. This example is a lamp-room tally, electric lamp relating to a rechargeable hand lamp by Gray-Sussmann for general use at Chanters.

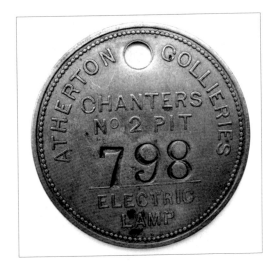

No. 2 pit example.

This time a lamp-room tally for a miners' oil safety lamp to be used down No. 2 pit; probably a Marsaut-type by Naylors of The Wiend, Wigan.

No. 1 pit oil-lamp tally.

General use lamp-room tally for oil lamps.

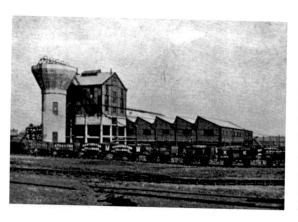

New washery and screen sheds were installed at Chanters by October 1927. This photograph is from *Carbon* magazine of October 1929 and, although poor in quality, is interesting due to the line of private-owner wagons, now part of the Manchester Collieries 'pool' in front. From the left, Atherton, Manchester Collieries, Bridgewater (Collieries & Wharves), A & T (Astley & Tyldesley Collieries), KK (Andrew Knowles, Pendlebury).

116

ENDLESS ROPE HAULAGE ENGINE
For the Arley Mine Workings.

Size : 12in. dia. by 18in. stroke.
Compressed air.

PART OF NEW ENDLESS ROPE
HAULAGE ROAD.

1¼ miles from the pit bottom in the Arley mine.
Depth about 820 yards.
Roof supported by Cambered girders.

A full-page feature in *Carbon* in October
1931 showing an endless-rope haulage engine
(compressed air) for the Arley workings. This was
used for wire-rope haulage on the level, tubs being
'lashed on' with chains to the rope. Often these
systems would run non-stop, the men and boys
having to lash on tubs as the rope moved. Many
fingers were lost over the years due to misjudging
the timing of this.

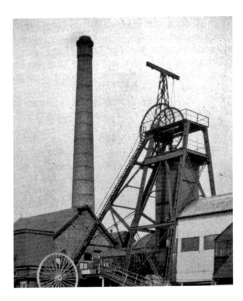

It's September 1933 and Chanters Colliery is
featured in *Carbon* magazine. Here, in shot is the
relatively new pit headgear at No. 2 pit of 1926 by
Naylors of Golborne. The girder above the headgear
allowed easy removal and replacement of pulley
wheels.

Chanters No. 2 was the 'upcast' shaft where air was drawn from the shaft and workings. Here, the unusual Waddle fan casing can be seen. Rather than a fan rotating inside a casing, the whole casing rotated. Curved blades spanned and joined the two halves of the casing propelling the air centrifugally outwards.

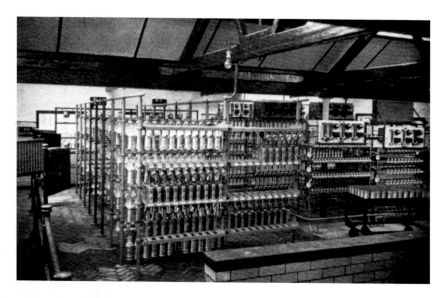

Electric lamps were first introduced at Chanters in 1914. By 1923, Gray-Sussmann 4-volt lamps were in place. In early 1933, the latest 2.6-volt alkaline lamps were ordered for use by colliers and also 100 cap lamps for those involved in special work, such as face work or tunnelling. Officials used special hand lamps and Wolf relighter oil lamps. In total, 800 electric lamps and a small number of oil lamps were installed; the new lamp room layout was finished by July 1933.

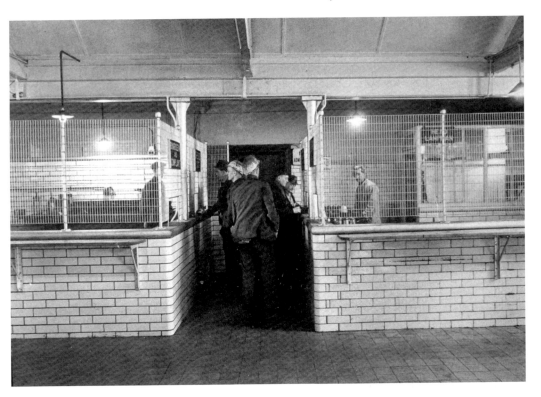

Above: Well-lit and clean issue area in the lamp room, possibly taken shortly after nationalisation in 1947.

Right: John has worked six days at Chanters, for many men a normal week. He has paid 6d to the Lancashire & Cheshire Miners Permanent Relief Society in case he was badly injured or killed at work. He still keeps in touch with his former employers through his penny to Atherton Collieries Joint Association. Grand total: £2 5s 9d.

CHANTERS PITS

W.E. 28.11.1936

MANCHESTER COLLIERIES LIMITED

2 4 7

John Barnes

6 .. @ 7/4½		2	4	5
Subsistence			8	3
Flat Rate - 1936			6	
..23.%			1	4
TOTAL		2	13	0
Rent				
Hag Fold Repayments				
Coal				1.
Health Insurance				1.0
Unemployment Insurance			9	
Holiday Savings				
Sick and Pensions				4.
Permanent Relief				6.
Convalescent Levy				7
A.C.J.A.				1.
TOTAL STOPPAGES			8	1
NET WAGES		2	5	9

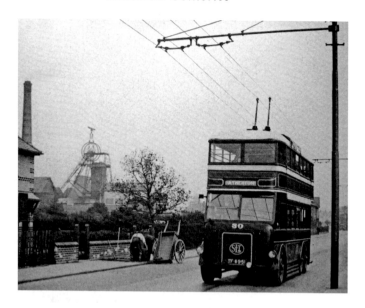

A superb, atmospheric scene from around late 1931 on Tyldesley Road with Chanters No. 2 in the distance. The house to the left is (as today) alongside the site of the Botanical Gardens Club. The trolley bus is a South Lancashire Tramways Guy. The last local trolley bus ran on 1 September 1958.

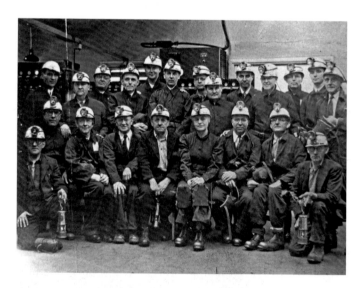

Manchester Collieries head office officials and visitors from Pennsylvania, *c.* 1947. Fifth from the right in the front row is Arnold Lowe, manager. He started with Fletcher Burrows in 1904, gained experience in Derbyshire pits, returning to Gibfield as undermanager in 1917. From 1924, he was manager at Howe Bridge, then in 1932, under Manchester Collieries, of both Howe Bridge and Gibfield. From 1939 to 1943, he was managing Brackley Colliery (Mcr Colls). In 1943, he managed Astley Green Colliery. After nationalisation in 1947, he was back at Atherton as the manager at Chanters until 1951.

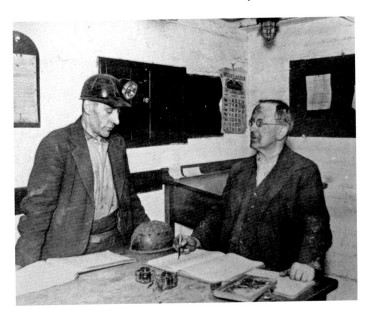

The calendar on the wall is for March 1942. William Hughes, undermanager down No. 1 pit from 1916 to 1945 is in his underground office. He started at Chanters in 1893 when horse haulage was still in use. He would have worked with men who remembered the sinking of the colliery. He had twenty years service with the rescue team and attended the Pretoria Pit, Over Hulton, disaster of 1910 when 344 men and boys died.

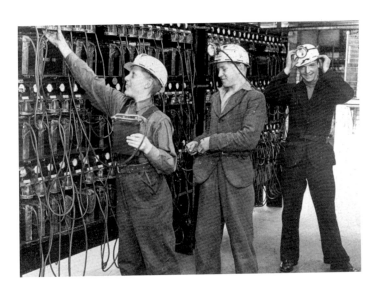

The training gallery was opened at Chanters No. 2 by January 1943. In the first year, 328 new entrants and refresher trainees from all the Manchester Collieries pits except Bradford passed through including 132 Bevin Boys. Here, excited young lads get their cap lamps and head off to the pit. They are wearing their old clothes, also lightweight, compressed card helmets made by Thetford. The miners' tally hung up near to the front boy's elbow says 'Chanters No. 2 Pit Day Shift' on it.

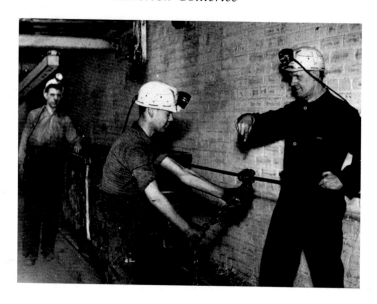

Below ground a young lad is being shown by Mr Crompton, the instructor, how to lash on his short chain with a hook at either end to the wire haulage rope to attach the line of tubs. A couple of 'lashes' of chain then overlap the hook over the chain; easy enough when the rope was static, but a different matter when it was moving. Then the lad had to allow a bit of slack chain before passing the hook over. He would do this by starting the process nearer to the tub. If he got it wrong, the chain would tense and off came a finger or two.

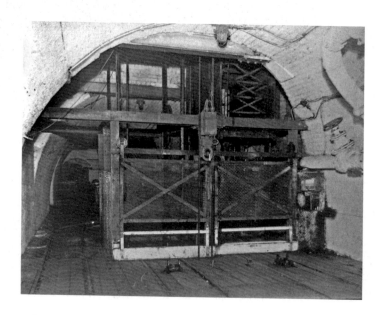

Pit bottom at the Five Quarters seam level. This was a shaft inset rather than a true 'pit bottom'. As part of the development of the seam in Manchester Collieries days, due to exhaustion of the Arley, this was created in 1941 at the 345-yard level. Four 12 cwt tubs were wound, totalling around 144 tons per hour.

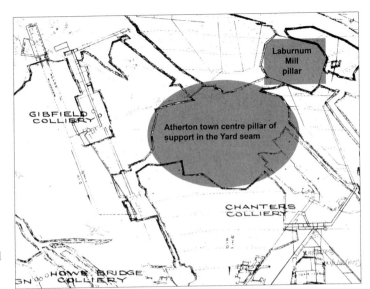

Colliery 'takes' barriers and boundaries in the Yard seam showing with modern overlays the huge pillars of unworked coal left to support Atherton town centre and Laburnum Mill (which is no longer there!).

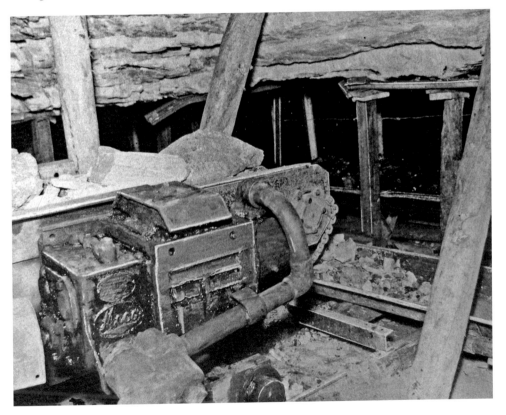

Yard seam. Meco shaker conveyor (it oscillated to and fro edging the stone along) delivering stone for building face and roadside packs. Rounded-end girder props, wood cappings and corrugated strap bars support the face line behind.

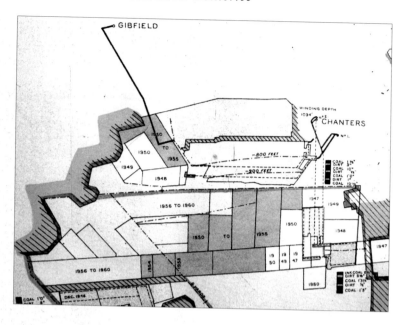

Manchester Collieries Technical Report from around 1946 showing phased working of the Five Quarters seam accessed to the south and south-west of Chanters shafts. The poor-quality seam section with three dirt bands deteriorated even more towards Bedford Colliery's take in the south.

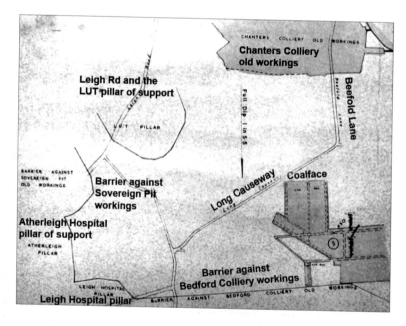

A variety of coal barriers and pillars to thwart full development of the Five Quarters, ranging from the pillar to support the old Atherleigh Workhouse (Hospital) to Leigh infirmary's pillar and one to support the LUT bus depot. Only the infirmary remains; the hundreds of thousands of tons of coal still lie there.

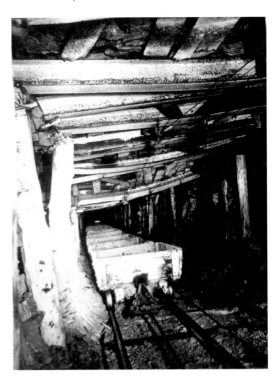

Right: The endless-rope man-riding 'train' in the south-west Five Quarters district. The carriages are clamped to the rope beneath, a return wheel at the bottom of the tunnel. Not much headroom part way down, the men just sitting in the flat-bottom carts and hoping a cross girder had not lowered due to roof pressure since the last shift.

Below: With the approach of nationalisation in January 1947 and compensation, Manchester Collieries here envisage working the Victoria seam at least until 1960. Whether they ever really intended to is another matter but in this case the seam was worked by Chanters after 1947 along with the Yard and Five Quarters seams.

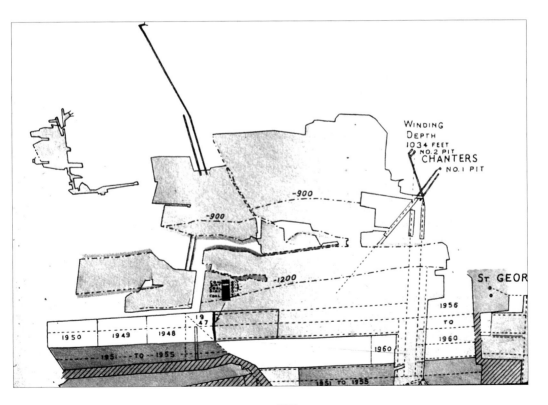

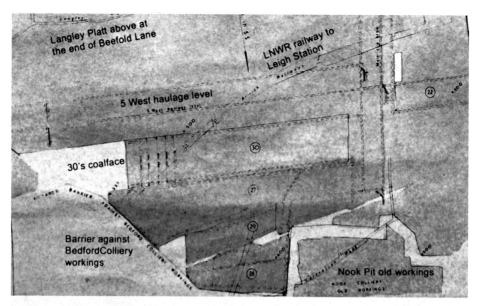

Manchester Collieries Technical Report from around 1946. Victoria seam old workings and proposed workings colour coded.

o-6-o internal-cylinder loco *Witch* had been transferred from Walkden Yard workshops to Chanters about July 1962 to replace loco *Violet* which had come from Gin Pit, Tyldesley, during the Second World War. Built in 1946 by the Hunslet Engine Company Ltd, Leeds, the loco left Chanters for Walkden around early 1965.

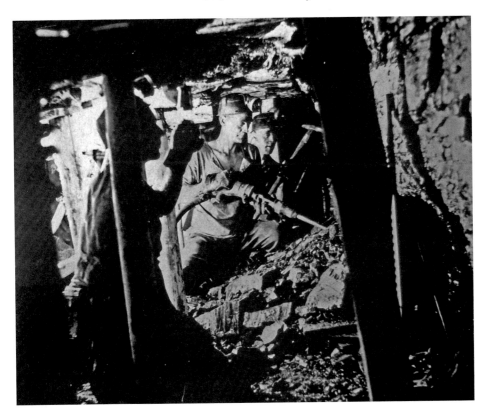

Above: Compressed-air picks in use at this rise coalface around the late 1940s. Although making the job of breaking the coal down far easier than with the hand pick, they created a large amount of deadly dust, and there are no facemasks in sight.

Right: Plodder seam West Brow 54's return junction. Skilled men were needed to set up complex junctions, often specialist contractors. The white material on the roof is stone dust thrown on to comply with safety regulations. In the event of an explosion this dust would be dislodged and smother any coal dust, which itself can ignite.

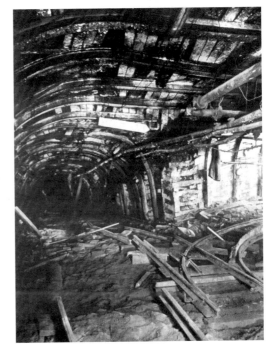

127

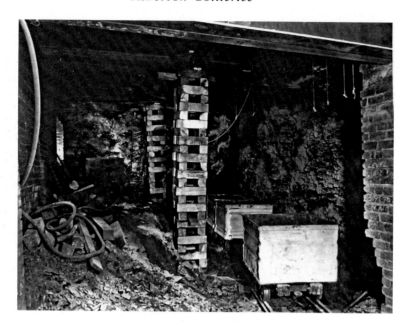

Plodder West Brow return roadway. Some sizeable chock stacks are in view. Lack of further details with the photograph but the brickwork and girders above could mean an air crossing was being set up. The strings hanging to the right were for setting out accurately the positions of the girders.

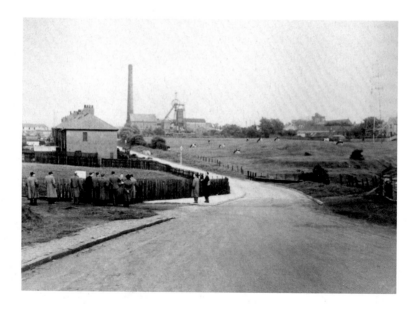

Tyldesley Old Road in the mid-1950s during a visit by Atherton Photographic Society. An old lady reminiscing back to the early 1800s via her father in *Carbon* magazine in the 1920s stated that 'many old ladder pits' existed down Tyldesley Old Road. The hummocky ground where the cows are grazing certainly looks to have been well dug. The Brassey seam outcropped there.

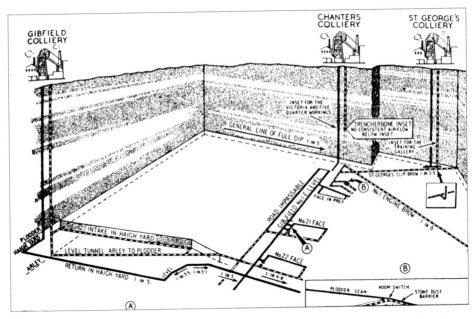

Surveyors drew up a plan for the official report into the explosion of 6 March 1957 showing how Chanters was linked to nearby collieries and why ventilation management had become difficult. A roof fall in one distant sector was all that was needed to upset the ventilation enough for gas to accumulate unexpectedly.

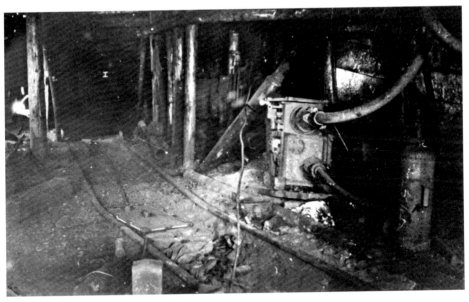

The site of the explosion at Chanters: an electrical switch box at a roadway high point, the lid of which had been opened while still live and in the unexpected presence of gas. Four were killed and four others died of burns a few days later. An electrical gas ignition in 1979 at Golborne Colliery resulted in ten men dying.

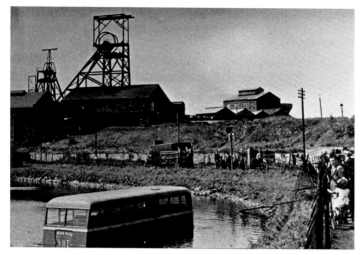

Nook Pit Tyldesley, August 1950, the LUT pit bus in the lodge. Through seam connections after 1929, the colliery became part of what was to be known as a 'water pond' stretching across Atherton and Tyldesley. This was mapped by area surveyors to assess the extent and direction of underground water movements.

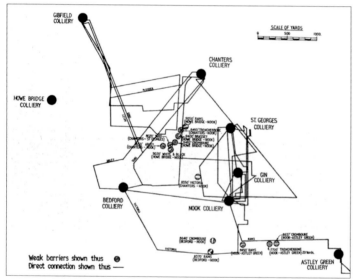

Area surveyors and engineers drew up this complex Atherton and Tyldesley 'water pond' in 1973 showing direct links between collieries and weak barriers between workings. Bear in mind also the 3-D nature of this assessment and you realise the skill involved. Imagine what the water situation may be like down there now.

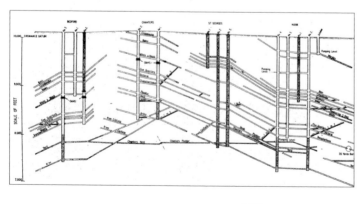

Cross-section of strata, Bedford Colliery, Leigh, to Chanters, St George's, to Nook Colliery, Tyldesley. This shows the links in various seams made after formation of Manchester Collieries in 1929, and later after 1947 in NCB days.

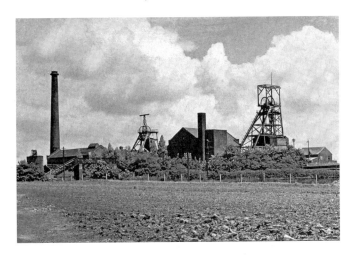

Bedford Colliery, Leigh, in the 1960s. Close to the site of the early 1800s Guests collieries. Guest was an early partner with the Fletchers in coalmining ventures. Bedford Colliery and Nook Colliery along with St George's Colliery, Tyldesley, were to become gradually linked to the Atherton mines after the formation of Manchester Collieries in 1929.

Mid-1960s. View towards No. 2 pit from the side of the pithead baths. Virtually identical in design to the example which still survives at Gibfield.

Mid-1960s. Behind No. 2 pit are some internal mineral wagons; older, wooden examples, possibly of pre-nationalisation age, and on the right, the standard, grey 16 tonner.

Mid-1960s, looking west. Very few images exist of the Chanters Sidings line which passed below Hindsford Bridge (now filled in and landscaped). Powys Street footbridge is visible in the distance. The line was funded by the LNWR and in operation by around early 1864.

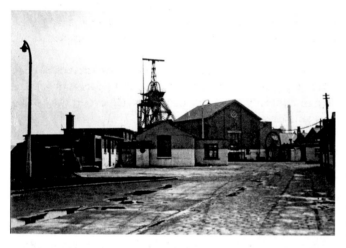

Mid-1960s. A view in the pit yard looking towards the chimney of Caleb Wrights Mill at Tyldesley. No. 1 pit headgear and engine house are prominent along with a spare headgear pulley wheel.

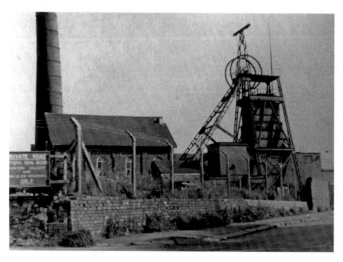

The sorry sight of Chanters No. 2 minus its winding ropes after closure in June 1966. The headgear was erected in 1926 by Naylors of Golborne. The square ventilation fan 'evasee' chimney can be seen at its base. To the left, the sign reads 'Private Road National Coal Board Chanters Colliery and Swan Island Brickworks Only'.

Mines Rescue

It is important to mention the major role Atherton played in the development of mines rescue, one which influenced coalmining rescue practice worldwide. From around 1850, a large number of colliery sinkings such as Howe Bridge and Chanters took place to ever-greater depths. Geological knowledge was now advanced enough to predict the coal reserves in districts and plan long-term high-capital enterprises. Ventilation, initially by furnaces, was being replaced by mechanical equipment, creating atmospheres conducive to full-blown explosions rather than minor gas ignitions. Larger numbers of men were being employed. Sooner or later, regular large explosions would be taking place with large losses of life.

In the early days, there was never a lack of volunteers to help in an attempt to save life or to recover bodies or to save a pit by taking part in fire-fighting operations, or to seal a district off following a fire or explosion. Colliery managers felt it their duty to be the first down into the workings and a number died.

These men had no special training and had no breathing apparatus, their safety oil lamps being the only indicator of the presence of gas or a lack of oxygen. Scientists and engineers worked to produce apparatus that could be used to save the lives of men involved in underground disasters. Usually most victims of such disasters were killed outright by the force of the blast, from carbon monoxide poisoning or died from burns a day or so after.

Henry Fleuss, as early as the 1880s, produced a compressed oxygen apparatus that was the forerunner of the 'Proto' apparatus later in use after 1908 at Howe Bridge Rescue Station. Specialised training was needed in the use of the apparatus, and in 1886, a Royal Commission recommended the establishment of rescue stations. By 1902, the first rescue station in Britain was set up at Tankersley near Barnsley. This was really an adapted house, but a step in the right direction, serving a number of local collieries.

Stations were not to be set up in all coalfields until the Coal Mines Act of 1911 made their provision compulsory. In 1906, a committee had been set up by the Lancashire & Cheshire Coal Owners Association to enquire into rescue equipment and techniques that might be employed in an organised manner in Lancashire. This preceded legislation by three years in the establishment of a central mines rescue station at Howe Bridge in 1908 to provide training and emergency cover for most of the Lancashire and Cheshire coalfield.

In order to select the most efficient and safest breathing apparatus, an invitation was sent to all makers of such apparatus, British and foreign, to compete in a series of tests lasting several days, in galleries filled with an irrespirable atmosphere, and fitted with various obstacles which the men had to surmount. The Fleuss apparatus, which had been considerably improved by Mr. R. H. Davis, and to which the name 'Proto' had been given, won the competition.

133

Shortly after the opening of the rescue station at Howe Bridge in April 1908, it was to be busy, its first call being to assist on 18 August at Maypole Colliery near Wigan, where seventy-five men and boys died after an explosion. This was the first recorded organised use of breathing apparatus in the Lancashire coalfield and one of the first in the country. There were only six trained men and a limited amount of apparatus at the station, it was realised that more men needed to be trained from the collieries themselves. Following the incident, a special medal was struck by the coal owners and each of the six men was presented with one. Two years later, on 21 December 1910, at the Pretoria Pit, Over Hulton, 344 men and boys were killed in an explosion followed by a coal-dust blast. Again, a medal was struck and awarded to some rescue men. This was the first time that several-hundred rescue men took part in an operation, showing how effective training based at Howe Bridge had become.

In Lancashire, Howe Bridge Rescue Station was followed by one at St Helens and another at Denton and was on call until the state-of-the-art Boothstown Mines Rescue Station, Ellenbrook Road, was built in 1934 close to the new East Lancashire Road. The 1907-8 Howe Bridge building down Lovers Lane still stands today next to the brook.

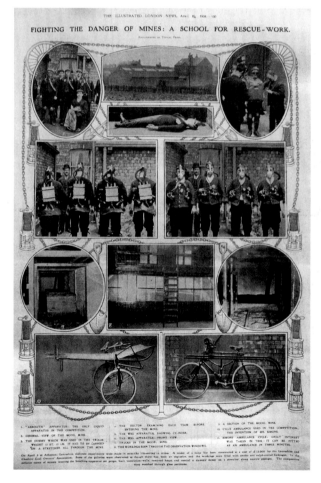

The *Illustrated London News*, 11 April 1908. The influential magazine ran a special feature on the opening of Howe Bridge Rescue Station with this full-page-illustrated layout. At the top is the station from behind, men displaying breathing apparatus, training galleries and a folding ambulance stretcher cycle.

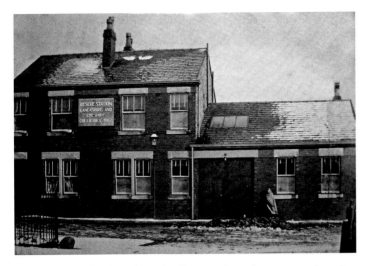

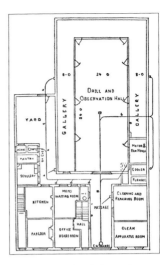

Above left: Thursday 2 April 1908, after what seems to have been a snow shower, this lady with distinctive shawl stands outside the newly opened Howe Bridge Rescue Station. Basically a couple of terraced houses with a large shed behind, but this was state of the art and of national importance. The building still stands today.

Above right: The station layout with room for maintaining apparatus, a main drilling and practice observation area, and training gallery tunnels which could be filled with obstructions and fumes. Eight doors allow various stages of an exercise in the galleries to be observed by instructors and men in the observation hall.

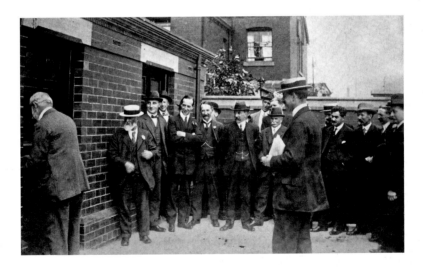

The official opening. The small man second left is John Gerrard, HM Inspector of Mines, who would be busy at the Maypole disaster in Wigan four months later, then Pretoria Pit in December 1910. Also present were W. Garforth, president of the Mining Association of Great Britain, Henry Hall, HM Inspector, scientist Dr Haldane, Charles Pilkington, Ralph Fletcher, J. S. Burrows and others.

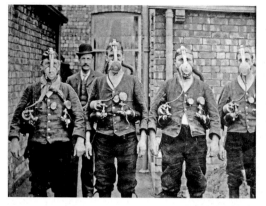

A team of men trying the WEG apparatus during the competition on the opening day. This was to find the equipment the committee felt most suitable to use at the station and on call out. Others included Siebe Gorman's Fleuss, Draeger, Clarke Steavenson and Valor designs. The Fleuss 'Proto' apparatus came out the winner.

A drawing from the *Illustrated London News*. A rescue man tests out the WEG apparatus in the training gallery, which has realistically been filled with obstructions and fumes.

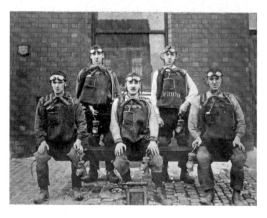

Photographed around 1919 outside the Gardener's Arms opposite the rescue station, these men have completed their course. On the floor is a canary-reviving apparatus with its small oxygen cylinder on top. The Proto breathing apparatus lasted for a minimum period of two hours hard work, the wearer breathed the same air repeatedly. At each exhalation the air was purified, and immediately before inhaling, a little oxygen was added to the purified exhaled air to take the place of the oxygen absorbed into the body at the previous breath.

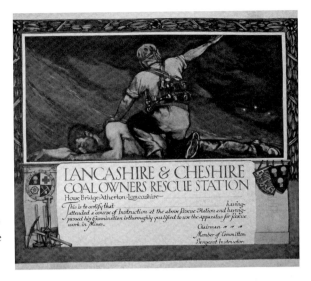

Rescue man's certificate. These began to be issued shortly after the station opened. The artist was Gordon Forsyth, an eminent designer and ceramic illustrator at Pilkington's Royal Lancastrian Pottery, Clifton, Manchester. Charles Pilkington was a coal-owner member of the committee. He was a director of Clifton & Kersley Coal Co. near Clifton, whose mines the Fletchers had developed back in the eighteenth century.

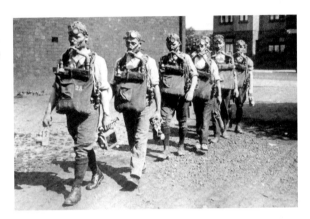

By 1932, a permanent full-time rescue brigade had been trained, based at Howe Bridge. Here, they are having a walk near the station with their apparatus donned. These men had to be supremely fit. To enter a mine full of gas or low in oxygen after an incident wearing breathing sets working through a mass of damaged ironwork and equipment to reach men took nerves of steel and great strength. To get the 'dead weight' of a man out to the fresh-air base up and down inclines and over rough ground was quite a feat.

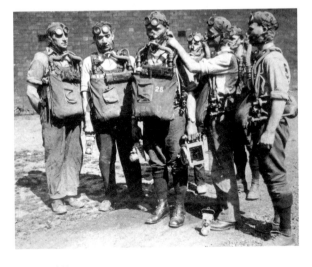

Men who work in fire and rescue teams and wear apparatus have always relied on each other to check their sets. The man being checked is carrying a canary-reviving cage and also an electric hand lamp of a type designed by Barnsley firm CEAG. Two years after this photo of 1932, Boothstown Mines Rescue Station opened, becoming the new central rescue station for the Lancashire coalfield.

Opencast

As well as mining via shafts and walk-in drifts, opencasting arrived after the Second World War with sites near Howe Bridge in the late 1940s, down Bee Fold Lane in the 1950s and 1960s and farther down Millers Lane and Bee Fold Lane again in the 1980s. This had been a wartime measure to boost coal production, many men serving in the forces in the early years of the conflict. The effect on coal production became so desperate that, by 1943, mining 'optants' and Bevin Boys were being drummed into the industry, some being trained at Chanters Colliery.

The late 1950s opencast, close to Howe Bridge church and Bee Fold Lane, uncovered early (probably late-eighteenth-century or early-nineteenth-century) workings. A man who worked on the site told me of tunnels exposed with shiny floors through the dragging of baskets, which were also found on site and 'thrown back into the workings'. The wartime opencast sites were often only excavated down to 30 or 50 feet. By the 1980s, sites were way down at close to 200 feet, on the verge of being classed as 'deep mining' operations.

Although opencast sites receive a great deal of opposition, for people like myself, they uncover our mining history, expose the local geology and can improve the land afterwards.

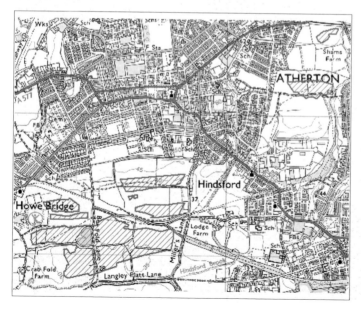

The shaded areas indicate where some of the opencast sites have been in Atherton from 1947 onwards. The Shams site up near central station operated from 1947-48 and extracted 24,551 tons of Rams and Brassey, the Crow Bank site of 1955-56 close to Shakerley Brook, west of Crawford Avenue, raised 83,852 tons of Black and White coal. The Crab Fold Howe Bridge site near Lilford woods of 1956-8 raised 97,549 tons, the Bee Fold site near Howe Bridge church of 1958-9 raised 23,833 tons of Brassey and Crombouke.

'Lancaster's Farm' opencast around 1957-9. A poor image but the only one of this site off Millers Lane. The view is towards Atherton town centre. Opencast at this time was not the 'exact' science it is today – just dig a hole with basic excavators and get the coal out. If only the old workings found had been photographed.

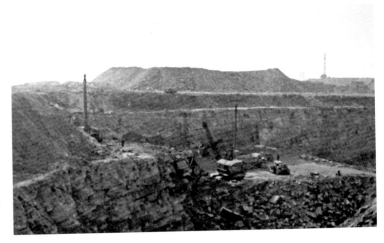

Sadly a poor photo of the Bee Fold site of 1958-9 with Howe Bridge station on the left. The photo is taken from the path at the side of Howe Bridge church. This opencast uncovered very early workings with 'shiny floored tunnels' accessed by the ladder pits near to the church, the cricket ground and Bee Fold Lane.

The opencast site of 1982-4 frustratingly did not turn up any old workings that I am aware of. Working the seams from the Riding to the Bin sensitivity to noise and dust was high among certain Atherton residents and regularly monitored.

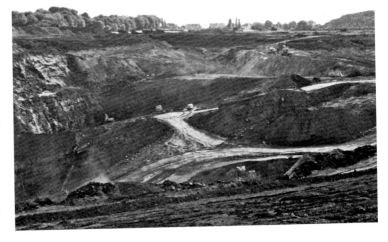

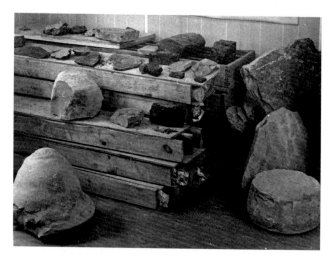

In the site offices, April 1984, core boxes are stacked up. On the left a 'bell pot'. These often fell out of the roof in tunnels killing miners. Having a flat base, they were not visible from beneath. On top at the back is an oval, flattened section of *Stigmaria* tree root. Lower right, behind another bell pot, is a section of ripple-marked stone, a reminder of the seas that once lapped on Atherton's beaches 200 to 300 million years ago, then near the equator.

Above left: Hand cleaning the 4-foot-2-inch Bin seam. These two men in a way were Atherton's last ever coalminers! This practice is not allowed on sites any more.

Above right: The 'hanging wall' at the 1982-4 opencast was not far off 200 feet high at its greatest. Here the Bin seam coal is being loaded into one of Bradley's wagons. These days, coal is loaded after screening near the site offices avoiding ordinary wagons potentially getting bogged down.

Swan Island Brickworks

Adjacent to Chanters Colliery, Swan Island brickworks and quarry was operated from around 1902 until shortly before the colliery closed; the site was then filled in with local refuse. In the early days, men had to tram the tubs all the way out to the brickworks. Later, as it became deeper, they had the use of an endless chain haulage system. The Crombouke, Brassey, and two other thin seams outcropped within the quarry – very handy for firing the kilns.

The geological survey photographed Swan Island for its memoir on sheet 85 in 1931. Here, two of Mr Smith's quarrymen stand precariously on clay boulders, which they will prise down to the quarry floor. Above them is the 4-foot-thick Brassey seam dipping at 1 in 5, or 12 degrees. Boulder clay rests on top of the coal seam.

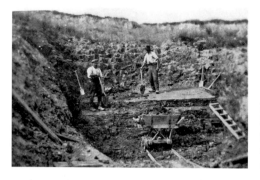

Late 1920s. At the 'clay face' these men are laboriously digging boulder clay lying on top of the Brassey seam. A tough job in the middle of winter no doubt. The earlier side-tipping wagons used on site run on simple angle iron rails.

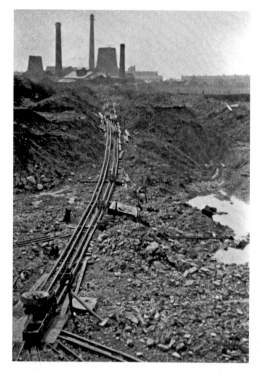

1930s photo by owner Mr Smith. The quarry is now using an endless-chain haulage system to get tubs out, at the same time bringing empties down. The chain located in a raised slot on top of the tub. Here we see the chain return wheel with empties stacking up as the chain rises and is detached. Chanters Colliery is in the distance.

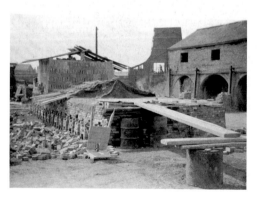

1930s. The kilns are to the right, the stack of fired bricks is being built up in the foreground. Chanters Colliery's wooden-slatted cooling tower near No. 2 pit is behind.

The Pretoria Disaster

A whole book could be written just on the Pretoria Pit disaster of 21 December 1910. 344 men and boys died due to an ignition of gas firing coal dust. Pretoria Colliery was in Over Hulton, not Atherton, so strictly does not merit inclusion in this book. With the centenary in 2010, I am sure many types of publication will be produced. I cannot resist, however, including a few photographs, as my grandfather was involved in clear-up operations underground after the disaster.

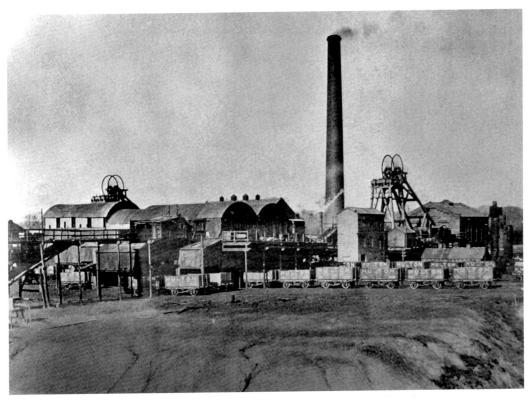

Pretoria Colliery, Over Hulton, lay just over the northern boundary of Atherton. The shafts were sunk in 1900-1901 accessing the Trencherbone, Plodder and Yard seams, the Arley Mine at 1,274 feet. This view may have been taken shortly after the disaster but the colliery layout would not have changed much. Twenty-three men from Atherton died in the disaster where 344 men and boys lost their lives.

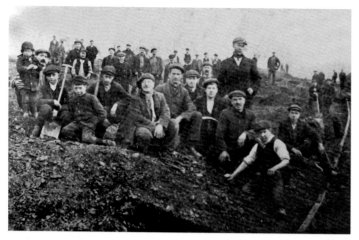

Coal picking during the 1912 strike on Pretoria 'rucks'. These men must all have lost many friends and workmates in the disaster of two years earlier.
The size of the Pretoria disaster is so enormous it is hard to imagine how communities such as Westhoughton could ever recover; it must have taken generations.

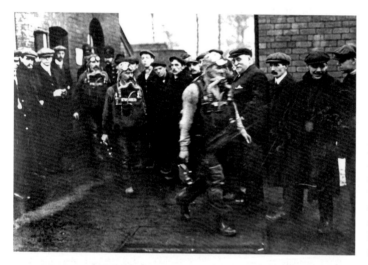

Rescue men recently trained at Howe Bridge Rescue Station, J. Robinson, J. Touhey and R. Picton, head off to the pit after the explosion. What a sight they have ahead of them: bodies in all manner of disfigurement, extreme explosion damage to battle through. Only three survived the explosion.

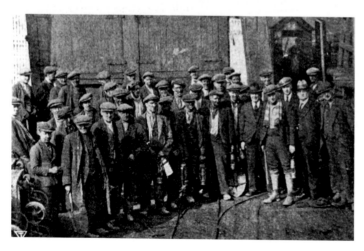

The last winding of men at Pretoria after it closed in August 1934. Who can imagine the feelings some of the older men in the photograph must have had as they travelled that shaft for the last time, the headgear of which had been badly damaged by the force of the blast in 1910. The shaft is today capped but open beneath; if ever bricks could tell a story, those in the shaft at Pretoria can.

Fatal Accidents at Atherton Collieries

From the earliest days of mining, men, women, boys and girls have died below ground. Even experienced miners, after a lifetime's work in the pit, could eventually be caught out by that unexpected roof fall or an accident while working with machinery. Atherton's mines had an enviable safety record with Gibfield featuring at the top of the region's records many times. The other two mines were never too far behind. No matter what the safety culture, accidents will always happen in mines and, luckily, Atherton did not suffer a major disaster (Pretoria was not strictly an Atherton mine, although many Atherton miners died there).

Including the Chanters explosion of 1957 where eight died and the Lovers Lane disaster of 1872 where twenty-seven died, I have arrived at a figure of 205 killed between 1850 and 1959. The reports of the Inspector of Mines only begin in 1850 so, when we consider that mining really took off in the late eighteenth century in Atherton, we can probably add ten or twenty at least to the total. Detailed returns were not made during the First World War.

REPORTED IN THE INSPECTOR OF MINES RETURNS, 1850 TO 1959

1850
February. Five men killed and a great many badly burned at Mr Fletchers' Gibfield Colliery, ignition of gas by candle.
[This seems to have been a full-blown explosion rather than a localised ignition; candles were used at this time but not for gas testing or in areas where gas was known to exist.]

1852
June 25. W. Whittle, roof fall while drawing a prop. No location.
October 7. P. Platt crushed by wagons on a branch siding. No location.
December 16. John Atkinson, drawer, killed by a fall of coal. No location, owners stated as Ralph Fletcher & Partners.

1853
No fatalities.

1854
February 16. S. Ashcroft, 22, explosion of firedamp. No location.

1855

July 21. A. Holden killed by a shot hanging fire [delayed ignition, firing as he returned]. No location.

October 17. J. Rigby, shaft sinker, killed by the explosion of a shot in ramming [the shothole]. No location, possibly Howe Bridge.

October 23. W. Speakman, 19 and W. Charlton, explosion of firedamp at Gibfield after using a candle to test for gas.

1856

February 6. J. Grimes, 16, drawer. Fall of coal in Lovers Lane Pit.

May 9. F. Hampson, 18, run over by wagon at Gibfield.

October 22. J. Banks, explosion of firedamp at Gibfield. Outburst of firedamp from the floor of the Five Feet Mine.

1857

No fatalities.

1858

May 25. John Riley, 19, explosion of firedamp at Howe Bridge, died June 4th.

October 27. John Lee, 32, wagon man, trapped between buffers on Gibfield sidings.

1859

April 8. James Arrowsmith, 12, greaser, crushed to death while trying to pass under the pumping cranks in the engine house at Howe Bridge. [A terrible accident to a young lad. This would be beneath the 'A' linkages, which connected the engine with the shaft pump rods on the old John Bull pumping engine]

July 1. William Smith, 15. Gibfield. Gunpowder exploded in his pocket. Died on July 10th.

December 24. David Critchley and R. Wood, firedamp explosion in the Rams Mine at Howe Bridge. Wood died on January 4th.

1860

No fatalities.

1861

No fatalities.

1862

March 10. John Smith, 26, crushed between two coal wagons on Lovers Lane sidings.

September 5. P. Cowburn 16, waggoner, crushed by a wagon after a jig brow chain broke in the Howe Bridge Six Feet [Rams] Mine. He died on September 7.

1863

No fatalities.

1864

April 26. Wm. Harrison, 12, waggoner, over run by a full tub running away down a brow at Gibfield.

1865
October 30. William Thorpe, 36, coal fall at Gibfield.

1866
February 2. James Hatton, 16, roof and coal fall in the Seven Foot Mine in the Volunteer Pit, Howe Bridge.
November 15. George Hall, 46, furnaceman, crushed by a descending cage while he was getting out at the top of the shaft. No location.

1867
February 8. William Molyneux, 26, coal fall, Six Feet Mine Howe Bridge.
March 8. Wm. Ashurst, 34, roof fall, Six Feet Mine Howe Bridge.
June 25. Wm. Gregory, 40. Howe Bridge. Early return to a shot, died in Bolton Infirmary July 8.
September 24. Peter Aldred, 23, hooker on, killed by tubs coming off the rails at the top of the haulage engine brow at Chanters.
November 13. Henry Marginson, 34, roof fall, Crombouke Mine, Howe Bridge.

1868
April 8. Charles Rothwell, 24, coal fall, Seven Feet Mine Howe Bridge.

1869
November 3. Wm. Landers, 30, coal and roof fall, Howe Bridge.

1870
January 27. Arthur Lee, 36, killed by stemming blown out by a shot in the Five Feet Mine, Howe Bridge.
March 31. Robert Cowburn, hit by a windlass handle [probably for lowering tubs down inclines to the haulage level], which he had let go of in the Five Feet Mine at Howe Bridge.
June 6. William Edwards, 33, coal fall Six Feet Mine Howe Bridge.

September 14. Wm. Seddon, 33, roof fall Trencherbone Mine Howe Bridge.
September 15. Frederick Bullough, 13, ticket clerk, crushed between railway wagons. No location.
October 8. James Charleson, 34 and Wm. Aldred, 11, a waggoner, explosion in the Crombouke Mine at Howe Bridge.
October 11. William Heald, banksman, caught by the engine brow rope while unhooking it from moving tubs in the Crombouke Day Eye at Howe Bridge.

1871
August 28. John Unsworth, 38, coal fall at Howe Bridge Six Feet.
November 8. Ralph Whittle, 20, falling coal Lovers Lane Five Feet Mine.

1872
March 28. Lovers Lane Colliery disaster 27 men killed. [listed in the main body of the book.]

October 1. Thos. Worthington, 36, miner, roof fall Chanters.

October 5. Hesekiah Staly, 30, blacksmith, wire rope broke as he was riding down the brow at the Crombouke Day Eye, Howe Bridge.

1873

July 27. John Lorrison, 23, coal fall at Chanters.

1874

May 25. Matthew Hayes, 35, fireman, roof fall at Lovers Lane.

July 11. Thos. Ridgeway, tunneller, falling stone at Lovers Lane. Died October 8.

1875

June 15. Richard Aldred, 48, slipped into the cage road above the sump at Lovers Lane.

September 8. John Smith, 32, coal fall at Lovers Lane.

October 12. J. Vestey. Howe Bridge. Injured in the Crombouke drift mine when coal rolled off sprags, died later at Bolton.

1876

January 6. Wm. Cleworth, 23, browman, run over by wagons while shunting with a horse at Howe Bridge.

1877

January 23. D. Rigby, 47, roof fall at Chanters.

March 7. Jos. Doyle, 47, roof fall at Gibfield.

March 13. Wm. Steward, 20, lifting a tub back on to the rails in the Crombouke Howe Bridge. Died on March 21.

April 12. Henry Higson, 20, coal fall at Gibfield.

May 2. John Seddon, 40, coal fall at Howe Bridge.

December 4. Wm. Owen, underlooker, caught in the jig brow when tubs became unhooked at the top. Chanters.

1878

October 17. Samuel Kersley, 65, spadesman, caught by a wagon on the siding at Howe Bridge Victoria.

1879

April 16. Michael Finnerley, 16, runaway tub at Howe Bridge Victoria died from injuries on December 16th, 1878.

May 13. Geo. Unsworth, 15. Howe Bridge. Tub he was riding in the Crombouke Day Eye came off the rails.

October 7. Joseph Collins, 26, stone fall in the Five Feet Mine at Chanters. He died on October 11.

November 7. Moses Cartwright, 20, coal fall at Chanters.

1880

May 21. Joseph Smith, foreman mechanic, accident while working on the wood lagging of a new conical drum winder in the engine house while the engine was still moving at Chanters Colliery.

June 10. John Tomblin, 16. Howe Bridge. Crushed by railway wagons on a siding at the Crombouke.

July 7. James Caldwell, 19, waggoner. Howe Bridge. Coal fall at the Crombouke.

1881

April 7. William Higgins, 48, labourer. Gibfield. Injured while moving poles for pit wood and died on April 30.

May 5. James Jones, 35. Chanters. Roof fall.

1882

January 18. James Holcroft, 39. Gibfield. Killed as he fired a shot.

April 16. Thos. Lee, 19, waggoner. Howe Bridge. Coal fall at the Crombouke, died on April 23.

May 23. James A. Seddon, 43, tub ran away on a balance brow at the Victoria, Howe Bridge.

1883

January 18. Two unidentified men, an underlooker and fireman, runaway tubs on the jig brow at Chanters.

March 12. R. Williams, 33. Howe Bridge. Roof fall in the Crombouke.

June 6. J. Morris, 48, coal fall at Lovers Lane, died on June 11.

July 13. W. Atkinson, 28, prop taker, removing a prop [in the waste area at the face] at Gibfield.

1884

February 1. Edward Jones, 40, taking coal down from the face at Gibfield.

February 2. Abraham Whittle, 14, waggoner. Howe Bridge. Crushed by tub in the Crombouke.

August 23. Wm. Preston, 38, fall of top coal at Chanters.

September 10. John Ball, 50, coal trimmer, by moving wagons in the sidings at Gibfield.

1885

January 27. James Walls, 35, fall of coal and middle dirt in the Arley Yard mine at Gibfield.

May 14. John Jones, 15, pony driver. No location. Crushed to death when a wheel broke on the tub on which he was riding.

October 19. William Pemberton, 49, coal screener, crushed between wagons being shunted at Gibfield.

December 3. William Henshaw, 10, wagon trimmer, crushed by a shunted wagon at Chanters.

1886

January 14. Giles Bolton, 27, drawer, run over by a tub at Gibfield Upper Arley Mine.

January 14. Richard Evans, 20, drawer, roof fall at Gibfield.

1887
January 13. Joseph Deakin, 42, roof fall at Chanters.
April 30. Peter McManus, 27, coal fall at Howe Bridge Victoria.
October 19. Thomas Roberts, 23, piece of coal rolling down onto him in Chanters Five Foot.
November 21. Edward Winstanley, 25. Gibfield. Scraped shoulder in fall of top dirt.
Infection, died in Manchester Infirmary on 29th December.

1888
January 13. Ephraim Booth, 30, roof fall at the Crombouke Day Eye, Howe Bridge after
tub knocked out a prop.
February 4. David McCoy, bank rider, tub coming off its carriage at the Victoria Howe
Bridge.
September 20. Estyn Young, 21, crushed by a full tub at Chanters.

1889
January 23. William Hunter, 23, and Luke Parkingson,19, fall of roof and top coal at
the Victoria Seven Feet.
October 7. John Rabbitt, 50, fall of top coal at the Victoria Seven Feet, Howe Bridge.

1890
September 16. James Thorpe, 43, fatal injuries in coal fall at the Victoria Seven Feet,
Howe Bridge. Died next day.
October 23. Daniel Long, 26. Howe Bridge Victoria. Died from injuries after tub
runaway incident of December 16, 1889.

1891
No fatalities.

1892
August 5. John Farnsworth, roof fall at Chanters.

August 23. William Perry, 25. Chanters. Prop sprung onto him after coal fall.
November 9. William Halton, crushed by tub, no location.

1893
May 8. John Dalton, 34, crushed by tub on the endless rope at Gibfield.
June 22. Samuel Brooks, 71, platelayer, slipped while screwing up a fishplate and hurt
his side at Atherton. He died later. [Might be on the surface.]

1894
May 1. Robert Benson, 22, powder explosion at Chanters.

1895
January 11. Simeon Pennington, 33, killed as he tried to enter a cage at an intermediate
level at Chanters Colliery before the return signal had been given.
October 22. John Peacock, 49, hit by empty train of tubs while cleaning a roadway at
Gibfield.

1896
No fatalities.

1897
March 2. Ernest Hague, 15, crushed by tubs in jig brow at Gibfield.

1898
June 9. John Valentine, 33, died in a roof fall at Chanters.
October 21. James Bates, 38. Chanters. Roof fall.

1899
February 10. John Hall, 29, roof fall at Gibfield.
March 10. William Barnish, 48. Howe Bridge Victoria. Roof fall.

1900
No fatalities.

1901
June 19. Thomas Bell, 26. Gibfield. Roof fall.
October 8. Thos. Battersby, 54, roof fall at Gibfield.

1902
February 18. James Charlson, 58, crushed by wagons at Gibfield.
April 2. Joseph Halliwell, 30, coal fall at Gibfield.

1903
February 13. Henry Davies, 50, dataller, crushed by a tub at Gibfield.
February 17. Theophilus Jones, 35, shaft sinker, bucket of stones hit the side of the frame at the Chanters Yard Mine landing, spilled its contents onto a gang of men 60 yards below who were sinking the shaft to the Arley. Six men were also injured.
August 21. George Dixon, 36, a collier, fall of coal at Chanters Yard Mine.

1904
July 4. James Smith, crushed by wagons [on surface] at Chanters.

1905
July 31. John Wm. Deeks, 34, fall of coal at Chanters.

1906
September 14. John Smith, 51, roof fall at Chanters.
September 27. Alfred Jameson, 26, runaway tub at Chanters.

1907
March 26. Henry Reeve, 41, coal fall in the Gibfield Yard Mine.

1908
No fatalities.

1909
August 5. Richard Chadwick, runaway tubs at Chanters.

1910
January 10. Patrick Loughlin, 45, peritonitis after being hit by fall of coal in the Howe Bridge Victoria Seven Feet.
March 7. William Hilton, 35, fireman, suffocated by firedamp, Gibfield Yard Mine.
October 8. James Marsh, 46, runaway tub at Chanters.

1911
March 17. Thomas Roberts, 47. Gibfield. Fall of sides in a main haulage road.
July 12. Arthur Edge, 47, hooker-on. Gibfield. Killed by descending cage as he put out his hand to raise the cage gate.

1912
No fatalities.

1913
February 27. John Hodgkinson, 66, assistant hooker-on [banksman], crushed to death at Chanters No. 1. Engineman raised the cage while he was still holding up the cage gate for men to enter.
May 2. Henry Greenfield, 17, head injuries at Chanters No. 2 while turning a full tub on the face
October 10. Michael O'Grady, 41, hit by tub. Gibfield. Died from his injuries on October 13.

1914
27 January. Michael McDonough, day wage man. Gibfield. Hit by stone. Died 29 January.
30 January. Noah Hampson, 43, day wage man. Chanters. Crushed beneath cage at shaft bottom while cleaning up.
15 July. John Carter, 20, collier. Roof fall. Gibfield.
2 November. James Green, 57, collier. Chanters. Roof fall.

1915
26 July. Edward Rothwell, day wage man. Chanters. Roof fall.

1916
15 July. George Banks, 15, tippler boy. Chanters. Died after knee injury.

1917
22 April. Wiliam Greenfield, 55, collier. Chanters. Fall of stone.
2 November. George Gerrard. Drawer, 15. runaway tubs. Chanters.
8 December. James Woodward, drawer, runaway tubs. Chanters. Died next day.

1918
28 June. Joseph Henshaw, fireman, 35, roof fall. Chanters.

1919
8 March. Thomas Croft, 40, contractor. Gibfield. Roof fall.

1925
21 January. Richard Humphries, 57, contractor. Gibfield. Fall of stone.
6 April. Michael Cullen, 63, collier. Gibfield. Roof fall.

1929
9 May. Joseph Bleasdale, 51, collier. Gibfield. Roof fall.

1933
20 October. Aaron Hardman, 42, collier. Chanters. Fall of roof.
28 December. Richard Jones, 40, day wage man. Chanters. Hit by tub.

1934
14 November. John Houghton, 20. Drawer. Gibfield.

1936
9 March. Samuel Lee, day wage man, 61. Chanters. Roof fall.
27 November. John Hodkinson, 27, drawer, Howe Bridge. Run into by tubs, died 5 December.

1938
5 August. William Marsh [possibly Walsh], 41, packer. Chanters. Roof fall.
14 November. John Hodgkinson, collier. Chanters, roof fall.
15 November. W. Hilton, 48, collier. Chanters. Roof fall. Died 15 November.

1939
20 April. Abraham Slater, collier. Chanters. Roof fall.
19 December. George Ashby, collier, 30. Chanters. Roof fall.

1940
August 24. Frederick Stott, 55, day wage man. Chanters. Fall of coal. Died 5th December.
September 15. John Mills, 40. Chanters. Fall of roof at face.

1941
14 May. Albert Stoves, 56, timber withdrawer. Chanters. Fall of ground.
16 June. Jack Counsell, ripper, 37. Chanters. Belt drive injury.

1942
24 October. Joseph Hall, 35, prop withdrawer. Chanters. Struck by prop, died 25th.

1943
January 27. Herbert Miller, 33, coalcutters asst. Chanters. Died 27 February.

1945
28 February. Clifford Halliwell, ripper, 40. Chanters. Fall of stone in the waste.

29 December. Eric Higson, 30, packer. Chanters. Roof fall.

1946
18 February. Charles Boyle, contractor, 27. Gibfield. Roof fall.
25 May. George Ibbotson, cutterman. Chanters. Coal fall.

1947
15 September. John Mills, cutterman. Chanters. Roof fall.

1948
Albert Whittle, conveyor mover. Howe Bridge. Coalface accident, died 7 September.

1949
22 July. Joseph Barlow, 31, collier. Chanters. Roof fall.

1953
2 March. Walter Sutton, 50, cutterman. Gibfield. Coal fall.

1955
15 October. John Hook, packer. Chanters. Fall of roof.
2 December. William Cooper, packer. Gibfield. Coal fall.

1956
17 January. Thomas Marley, repairer, Howe Bridge. Fall of stone.
15 February. Edward Orange, 58, repairer. Howe Bridge. Fall of stone.

1957
6 March 1957. 8 die as a result of the explosion at Chanters;
Killed instantly: Leslie Inman, 40, electrician, Thomas Morris, 23, mechanic's mate, Kenneth Tryner, 31, electrician's mate, Fred Woodward, 45, engine driver.
Died later of injuries: Wilfred Beckett, 29, repairer, Eric Nutter, 21, repairer, Walter Pearson, 36, mechanic, Pawel Socha, 46, contractor.

1958
23 July. William Liptrot, face worker. Chanters. Conveyor and coal cutter accident.
Colin Wolstenholme, 21, cutterman. Gibfield. Roof fall.

1959
20 January. Thomas Roberts, shotfirer, Howe Bridge. Belt accident.

Coal Production at Atherton Collieries

1872 TO 1919

Year	Tonnage	Year	Tonnage	Year	Tonnage
1873	258,638	1874	319,036	1875	326,008
1876	279,558	1877	385,156	1878	451,894
1879	489,915	1880	470,982	1881	455,096
1882	472,098	1883	442,110	1884	490,075
1885	525,255	1886	563,434	1887	582,113
1888	610,501	1889	598,769	1890	559,492
1891	578,081	1892	516,374	1893	359,354
1894	500,565	1895	465,509	1896	446,203
1897	462,777	1898	470,640	1899	477,958
1900	516,310	1901	518,356	1902	530,083
1903	531,470	1904	521,447	1905	536,496
1906	532,966	1907	565,474	1908	580,320
1909	580,632	1910	592,516	1911	627,538
1912	617,283	1913	669,566	1914	581,767
1915	554,048	1916	550,783	1917	608,039
1918	533,150	1919	507,533		

Note: From 1899 to 1919, the figures are annual coal sales. Coal used by the pits could easily amount to 30,000 tons a year.

COLLIERY OUTPUT IN NCB DAYS, 1947-1967

Year	Chanters	H. Bridge	Gibfield	Total
1947	373,174	127,490	215,140	715,804
1948	371,075	120,900	207,340	699,315
1949	350,973	135,557	204,323	690,853
1950	358,874	132,082	185,503	676,459
1951	367,123	138,201	205,137	710,461
1952	384,973	132,213	220,828	738,014
1953	412,818	147,278	256,875	816,971
1954	420,756	148,981	278,800	848,537
1955	427,214	140,531	269,713	837,458
1956	401,497	110,853	257,879	770,229

1957	424,229	89,226	244,760	758,215
1958	422,577	72,496	293,899	788,972
1959	393,201	49,065	277,720	720,014
1960	414,666	56,000	276,028	746,694
1961	396,375	C	188,571	584,946
1962	425,163	C	201,025	626,188
1963/64	372,410	C	69,844	442,254
1964/65	359,174	C	C	359,174
1965/66	298,802	C	C	298,802
1966/67	57,950	C	C	57,950

C = closed

Bibliography and Sources

Research compiled by Alan Davies, 1970 onwards.

Anderson, Donald, and J. Lane, *Mines and Miners of South Lancashire, 1870-1950* (Donald Anderson, 1980).

Ashworth, W., *The History of the British Coal Mining Industry. Vol. V, 1946-1982* (Oxford University Press, 1986).

Arnot, R., *The Miners. A History of the Miners' Federation of Great Britain, 1889-1910* (Allen & Unwin, 1949).

Arnot, R., *The Miners. Years of Stuggle: A History of the Miners' Federation of Great Britain, from 1910 Onwards* (Allen & Unwin, 1953).

Arnot, R., *The Miners. In Crisis and War: A History of the Miners' Federation of Great Britain from 1930 Onwards* (Allen & Unwin, 1961).

Ashton, T. S., and Joseph Sykes, *The Coal Industry of the Eighteenth Century* (Manchester University Press, 1964).

Bullman, H. F., *Coal Mining and the Coal Miner* (Methuen & Co., London, 1920).

Challinor, R., *The Lancashire and Cheshire Miners* (F. Graham, Newcastle, 1972).

Church, R., *The History of the British Coal Mining Industry. Vol. III, 1830-1913* (Oxford University Press, 1986).

Davies, Alan, *The Wigan Coalfield* (Tempus, 1999-2009).

Davies, Alan, *The Pit Brow Women of the Wigan Coalfield* (Tempus, 2006).

Flynn, M. W., *The History of the British Coal Mining Industry. Vol. II, 1700-1830* (Oxford University Press, 1984).

Griffin, A. R., *Coal Mining* (Longman, 1971).

Hannavy, J., and C. Ryan, *Living and Working in Wigan* (Smiths Books, Wigan, 1986).

Hatcher, J., *The History of the British Coal Mining Industry. Vol. I, Before 1700* (Oxford University Press, 1993)

Hayes, Geoff, *Collieries in the Manchester Coalfields* (Landmark, 2004).

Hickling, George, *Lancashire Sections of Strata* (Lancs & Cheshire Coal Association, 1927).

Hiley, Michael, *Victorian Working Women* (Gordon Fraser Gallery, 1979).

Holland, John, *The History and Description of Fossil Fuel, The Collieries, and Coal Trade of Great Britain* (Whittaker & Co., London, 1835).

Howarth, Ken, *Dark Days* (Greater Manchester County Council, 1978).

Lewis, B., *Coal Mining in the Eighteenth and Nineteenth Centuries* (Longman, London, 1971).

Lunn, John, *Atherton* (Atherton Council, 1971).

Mining Association, *Historical Review of Coal Mining* (Fleetway, c. 1924).

Pamely, Caleb, *The Colliery Manager's Handbook* (Crosby Lockwood, *c.*1904).

Percy, C. M., *Mining in the Victorian Era* (Thos Wall & Sons, Wigan, 1897).

Percy, C. M. (ed.), *The Science and Art of Mining* (Wall, Wigan, 1896).

Preece, G., *Coalmining* (City of Salford Cultural Services Dept, 1981).

Raistrick, A. and C. E. Marshall, *The Nature and Origin of Coal and Coal Seams* (English University Press, 1939).

Redmayne, R. A. S., *Modern Practice in Mining* series (Longmans Green & Co., 1911).

Sinclair, J., *Coal Mining Law* (Pitman, 1958).

Supple, B., *The History of the British Coal Mining Industry*. Vol. IV, 1913-1946. (Oxford University Press, 1987).

Townley, C. H. A., C. A. Appleton, J. A. Peden, and F. D. Smith, *The Industrial Railways of Bolton, Bury and the Manchester Coalfield, parts 1 and 2* (Runpast Publishing, 1994, 1995).

Wood, Ken, *The Coal Pits of Chowbent* (pub. K.Wood, 1984).

Carbon magazine, 1920-1929, 1929-1935; *Manchester Collieries Magazine* 1944, 1945, 1946.

Colliery Guardian.

The Colliery Manager.

The Graphic.

The Illustrated London News.

Lancashire Magazine.

The Leigh Chronicle.

The Leigh Journal.

The Manchester Guardian.

The Observer.

Pictorial World.

The Wigan Observer.

Catalogue of Plans of Abandoned Mines, HMSO, 1928.

The Coal Authority Mining Record Office Mansfield

Colliery Year Book & Coal Trades Directories, 1943 to 1962.

Concise History of the Bolton to Leigh Railway, Wigan MBC Leisure Dept, William Stuart, 1983.

Greater Manchester County Record Office, Atherton Colliery Records.

Guide to the Coalfields, 1948 to 1996.

Lancashire and Cheshire Antiquarian Society.

Lancashire and Cheshire Miners Federation minutes.

Lancashire Record Office DDLi Lilford Deposit, NCB records.

Memoirs of the Geological Survey, HMSO, sheets 84/1938, 85/1931.

Museum of Science & Industry.

The National Archives London, NCB records.

North Western Coalfields Regional Survey Report, Ministry of Fuel & Power, HMSO, 1945.

Records and library formerly held at the Lancashire Mining Museum Salford, now at
 Manchester
Reports of The Inspector of Mines, 1850 onwards, HMSO.
Transactions of Manchester Geological Society.
Transactions of the Institute of Mining Engineers.
Wigan Archive Service, records of Atherton Collieries Joint Association.

Further reading from Amberley

BLACK AVALANCHE
THE KNOCKSHINNOCH PIT DISASTER
Arthur & Mary Sellwood

Black Avalanche is a vivid account of the world's
strangest pit disaster. This book is written by a husband
and wife team who interviewed the survivors and rescue
workers involved in this terrible tragedy.

Price: £14.99
ISBN: 978-1-84868-245-0
Size: 235 x 156mm

Available from all good book shops and online
www.amberleybooks.com